Discover Art

Laura H. Chapman

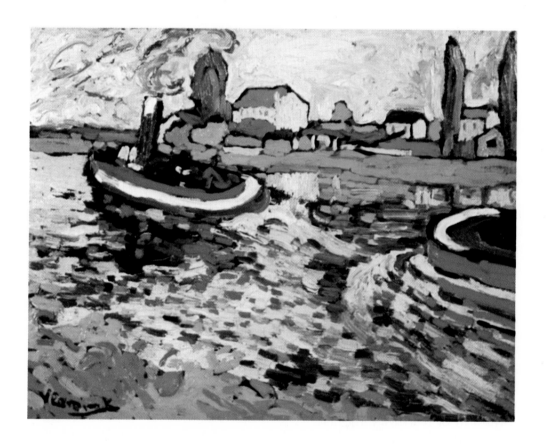

Grade 5

Davis Publications, Inc.

Worcester, Massachusetts

Title page: Maurice de Vlaminck,
Tugboat on the Seine, Chatou. Private
collection.

Printed in the United States of America
ISBN: 0-87192-157-X
SE 5

10 9 8

Acknowledgements: The author wishes to
acknowledge with gratitude the
contributions of principals, teachers and
students who participated in the field test,
the editorial and design staff of Davis
Publications, and the following individuals:
Gerald F. Brommer, author and artist, Los
Angeles; Nancy Denney, art teacher,
Brantner Elementary School, West
Clermont, Ohio; Joseph A. Gatto, Los
Angeles Public Schools; Carol Hartsock,
fiber artist; George F. Horn, formerly
Coordinator of Art, Baltimore Public
Schools; Barbara Marks, art teacher, Paxton
(Massachusetts) Center School; Gini
Mercurio, interior designer and editorial
assistant, Cincinnati, Ohio; Patricia A.
Renick, University of Cincinnati; Jerry
Samuelson, California State University at
Fullerton; Jack Selleck, Los Angeles Public
Schools; and Jack Stoops, formerly of
University of Washington and University of
California, Los Angeles.

Publisher's Note: The Publisher is indebted
to the author for her conceptualization and
for keen insight into the selection of the
visual materials for this series.

Managing Editor: Wyatt Wade
Production Editor: Margaret M. McCandless
Photo Acquisition and Editorial Assistance:
Laura J. Marshall
Claire Mowbray Golding
Graphic Design: Gary Fujiwara
Cover Design: Author
Illustrator: Joan Cunningham

Contents

Learning About Art
Seeing, Thinking, Imagining

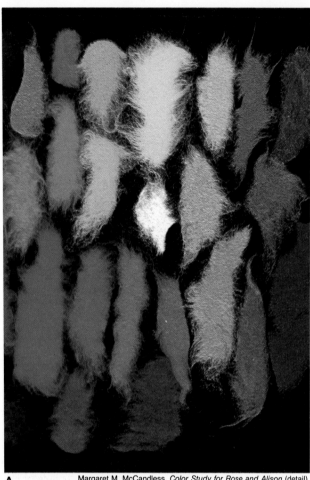

A Margaret M. McCandless, *Color Study for Rose and Alison* (detail), 1984. Wool felt, 9 × 8¾" (23 × 22 cm).

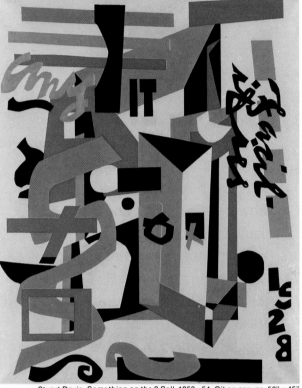

B Stuart Davis, *Something on the 8 Ball*, 1953 - 54. Oil on canvas, 56" x 45". Philadelphia Museum of Art, Pennsylvania (The Adele Haas Turner and Beatrice Pastorius Turner Memorial Fund).

This year you will learn many new things about art. Here are some important things to remember.

Use your eyes. Art begins with things you see and remember. Look around your classroom. How many kinds of blue do you see? Look for light and dark blues. Find blue-greens and blue-violets. Look for reds, yellows and other colors. Do some colors match the examples in picture A?

Use your imagination. Artists do. Stuart Davis, an American artist, created the painting shown in picture B. He enjoyed jazz music. He also liked the bright colors and shapes of signs that are crowded together in big cities.

Stuart Davis combined these ideas to create a painting filled with "jazzy" shapes and colors. What other parts of the painting show that the artist used his imagination?

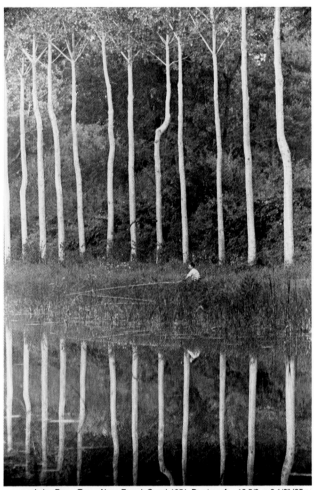

C Irving Penn, *Trees Along French Canal*, 1951. Dye transfer, 13 5/8 × 9 1/6" (35 × 23 cm). Collection, The Museum of Modern Art, New York (Gift of the photographer).

Think about things you see. In art, questions often have more than one correct answer. You can try this experiment with picture C.

Decide what feeling you get when you look at the photograph. On a slip of paper, write one word that describes this feeling. Collect the slips of paper. Find out if people describe similar or very different feelings.

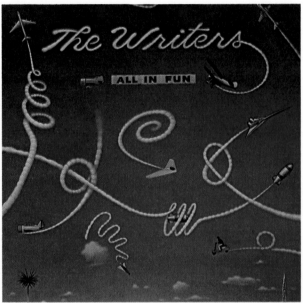

D *The Writers: All in Fun.* CBS record album cover. Illustrator: David Wilcox.

Study the art in your environment. An artist designed the record cover in picture D. What lines do you see in the cover design? What else did the artist want you to see and think about?

Today you will draw a picture from memory. Draw the front of your house or apartment. Try to remember and draw it just as it looks.

Drawing
Motion and Change

Children your age drew the pictures you see in this lesson. They drew pictures to explain how things can move and change.

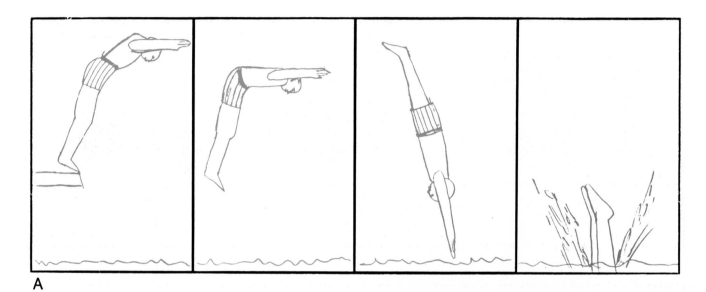

A

The boy who drew these pictures is a good swimmer. He drew four pictures to show the motion in a good dive.

Artists make pictures similar to these. The artists are called **illustrators**. An illustration is a picture that explains something.

Some illustrators are cartoonists. They draw funny pictures or comic strips.

A child drew the cartoon shown here. How did she show change and motion?

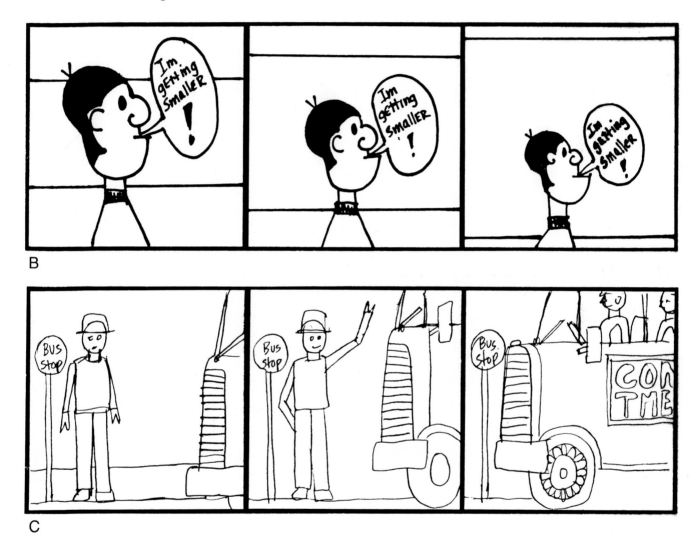

B

C

Think of other things that move and change. Think of an original idea. Original art is your own work. It is not copied. Explain your idea by drawing three or four pictures on one sheet of paper.

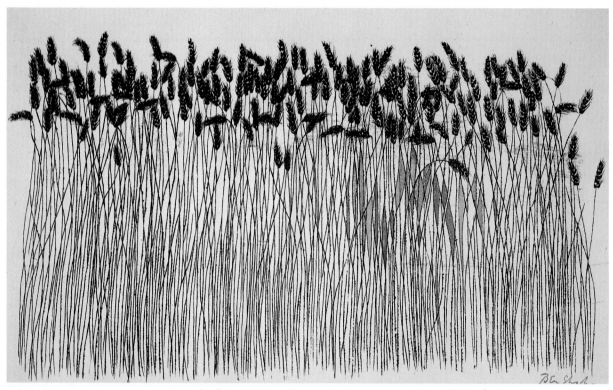

A

Ben Shahn, *Wheat Field*. Serigraph, colored by hand. National Gallery of Art, Washington, D.C. (Rosenwald Collection).

There are many ways to get ideas for art-work. Try drawing things you see in nature. This is an important way to get ideas.

Ben Shahn, an American artist, created this work of art. He drew the thin delicate lines of wheat stalks. He also drew lines to show the shape and texture of the wheat tassels.

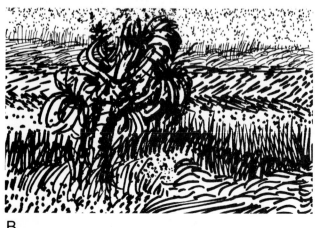

B

Artists learn to draw many kinds of lines. Some artists draw scenes of the countryside. In this drawing, look for different kinds of lines that suggest textures and patterns.

Charles Burchfield, an American artist, drew lines to show that thistles are prickly. Can you describe some of the lines he used?

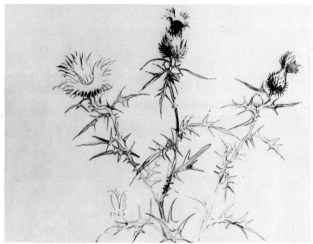

C Charles Burchfield, *Study of Thistle,* 1961. Crayon, 13¼ × 18⅞″ (34 × 48 cm). Whitney Museum of American Art, New York.

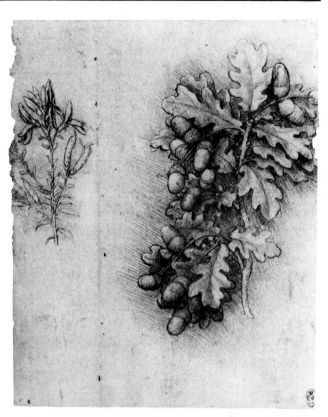

D Leonardo Da Vinci, *Oak Leaves with Acorns and Dyers' Greenwood, ca.* 1505. The Royal Library, Windsor, England.

Leonardo da Vinci was a famous artist, scientist and inventor. He lived in Italy more than 480 years ago. What lines do you see in his drawing? How did he draw shadows?

Today you will draw a leaf, twig or something else in nature. Draw the main shapes very lightly, then draw lines to show the edges and details.

Use your pencil in different ways. Create lines that show whether your object is delicate or strong, rough or smooth, flat or rounded.

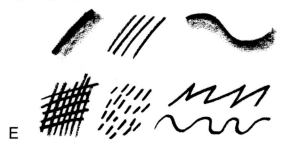

E

Lines, Textures and Patterns
Crayon Etching

A From *Drawing: Ideas, Materials and Techniques* by Gerald Brommer, 1978. (Davis Publications).

B

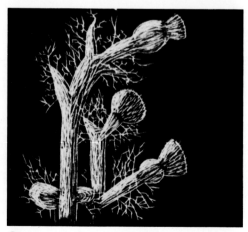

C

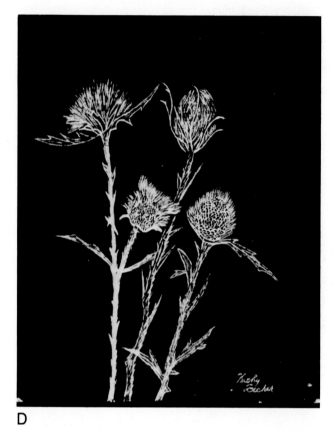

D

There are many techniques (tek-NEEKS) for using pencils, crayons, and other art materials. A **technique** is a planned way to do something.

The drawings in pictures A, B, C and D are examples of a technique for using crayons. The technique is often called **crayon etching**.

You can try this technique. Follow the steps on the next page. "Etch" a picture of the object that you drew in Lesson 3.

When you have finished, compare your pencil drawing and your crayon etching. If you like one picture more than the other, try to explain why.

Crayon Etching

1. Use light colors of crayon. Color any design that you like. Press very hard and cover the whole paper.

2. Now color the whole paper again with black crayon. Press very hard. The black should cover up your first design. You now have two layers of crayon on your paper.

3. Use a nail or another object with a point. Scratch your drawing into the black layer of crayon so that the light colors show.

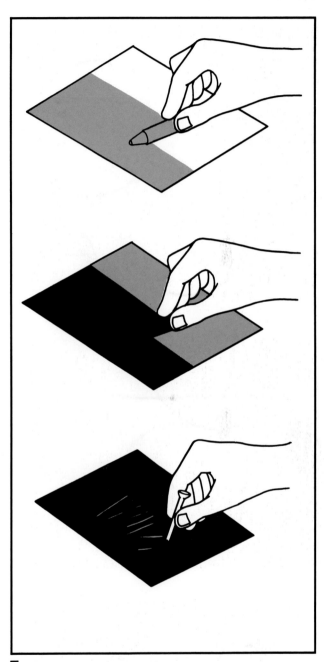

E

4. You can create different kinds of lines, textures and patterns. If you want to change your etched lines, color them out with black crayon and scratch new lines.

F

Artists plan their drawings and paintings. They can plan a tall, vertical picture. They can plan a wide, horizontal picture. Some artists like to make square pictures.

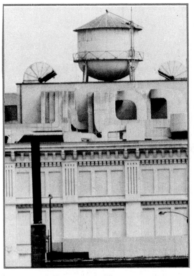

B

You can learn to look for pictures to draw or to paint. You can plan the shapes of the pictures you create. Use a viewfinder to find ideas for your artwork. A viewfinder is a sheet of paper with a hole in it.

A

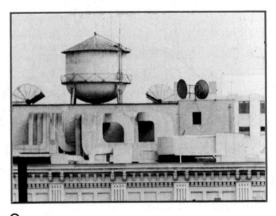

C

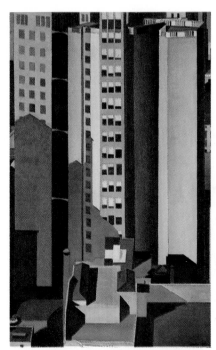

Some artists make many different pictures of the same subject. Charles Sheeler liked to create art about the city. He planned the shapes of his pictures to show the city in different ways.

D Charles Sheeler, *Offices*, 1922. Oil on canvas, 20 × 13″ (51 × 33 cm). The Phillips Collection, Washington, D.C.

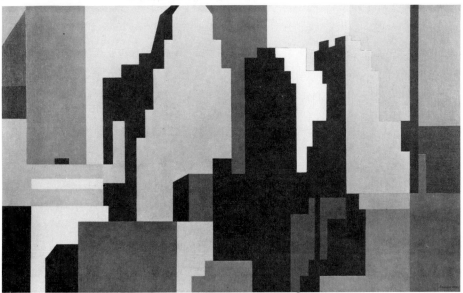

E Charles Sheeler, *Skyline*, 1950. Oil on canvas, 25 × 40″ (63 × 102 cm). Collection, The Wichita Art Museum, Kansas.

F

You can learn to plan the shape of your pictures. Make sketches of something you see in the classroom or outside the window. Make each sketch a different shape.

15

Colors
Pure, Warm, Cool, Neutral

Color Wheel

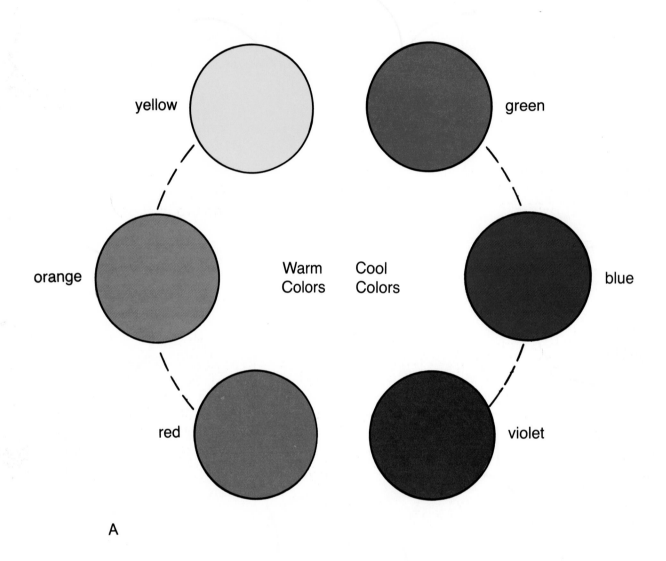

A

This is a color wheel. It shows the pure colors you see in a rainbow. Rainbow colors are seen when light shines through raindrops.

You can also see pure colors when light shines through a prism. The colors of other objects are called **pure** or intense when they look like colors from a rainbow or prism.

Red, yellow and orange are called **warm colors**. Warm colors often remind people of warm feelings or warm things such as the sun or fire.

Blue, green and violet are called **cool colors**. Cool colors often remind people of cool feelings or cool things such as water and ice.

There are many other families of colors.

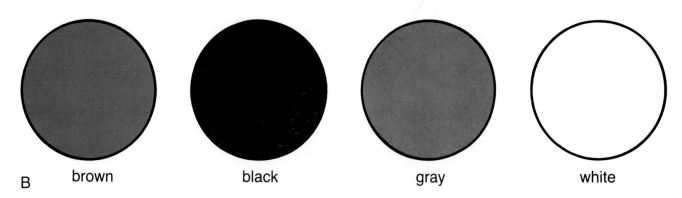

B brown black gray white

Brown, black, gray and white are not colors that you see in a rainbow or prism. Artists call these **neutral colors**.

A neutral color can be changed by adding warm or cool colors to it. Perhaps you have heard of a "warm brown" or a "cool gray."

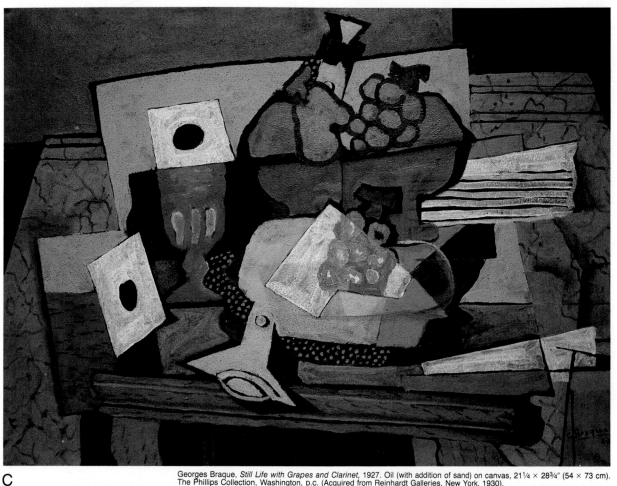

C

Georges Braque, *Still Life with Grapes and Clarinet*, 1927. Oil (with addition of sand) on canvas, 21¼ × 28¾" (54 × 73 cm). The Phillips Collection, Washington, D.C. (Acquired from Reinhardt Galleries, New York, 1930).

George Braque, a French artist, created this still life painting. Are most of the neutral colors warm or cool?

Draw a picture with many neutral colors. Add other colors to make the neutral colors look warm or cool.

Colors
Warm and Cool Colors

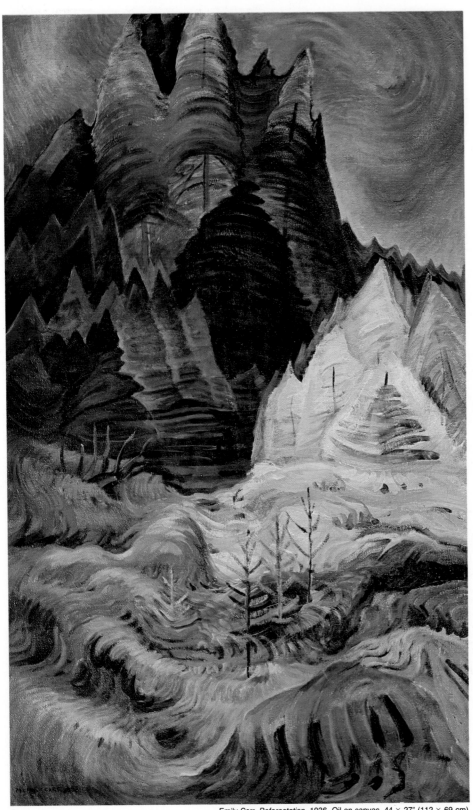

A

Emily Carr, *Reforestation*, 1936. Oil on canvas, 44 × 27″ (112 × 69 cm).
The McMichael Canadian Collectioin, Kleinburg, Ontario.

Emily Carr created many paintings about the great forests of western Canada. In picture A, *Reforestation*, she used many cool colors. The cool colors help you see and imagine the coolness of the forest.

Notice how the artist mixed green with blue, violet and yellow. What other colors do you see?

Georgia O'Keeffe used many warm colors in her painting about the mountains in New Mexico. The warm colors help you see and imagine the red earth and heat in the sun-baked desert. What other colors did the artist use?

What kind of picture could you draw with warm or cool colors?

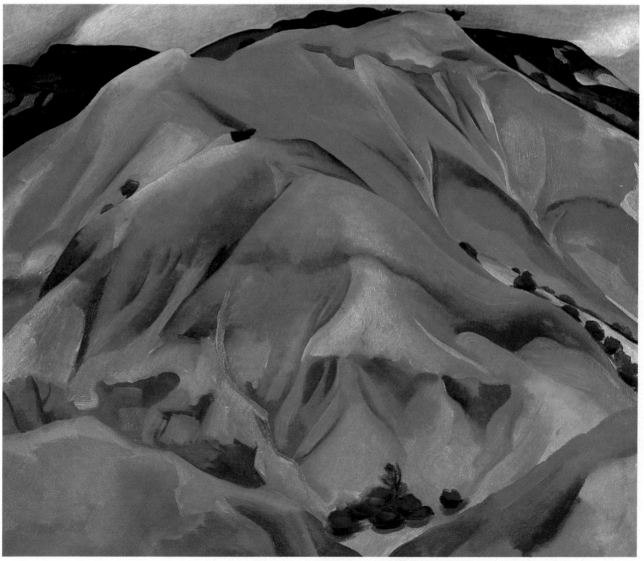

B

Georgia O'Keeffe, *The Mountain, New Mexico*, 1931. Oil on canvas, 30 × 36″ (76 × 91 cm). Whitney Museum of American Art, New York.

Painting
Ways to Use Paint

Today you will use tempera paint. There are many techniques for using paint. A technique is a way to do something very well.

Artists learn techniques so they can express ideas and feelings in artwork. Study the examples of painting techniques in pictures A, B and C. How could they be used to express ideas and feelings?

A Thick paint and a wet brush

B Thick paint and a dry brush

C Thin "watery" paint on wet paper

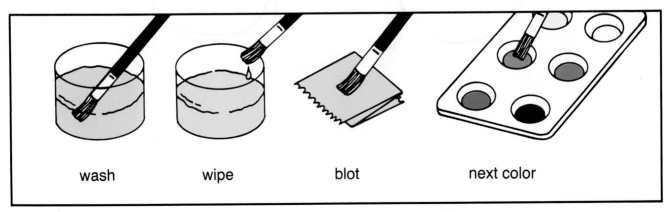

wash wipe blot next color

D Use your tempera paints this way. Do you know why?

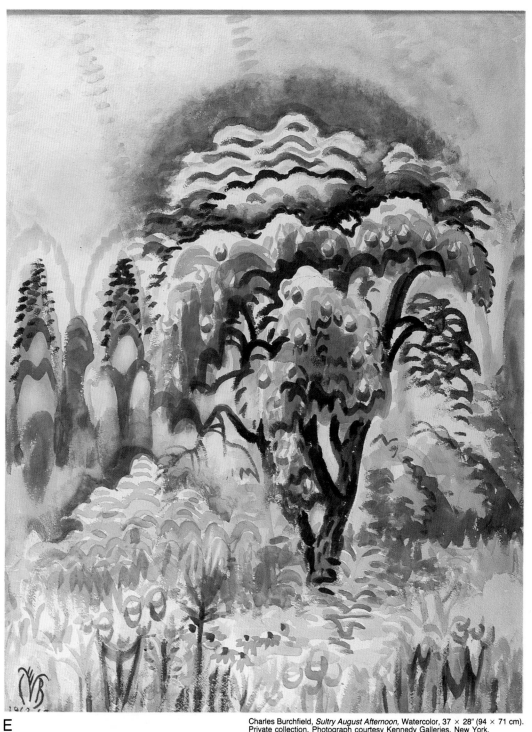

E

Charles Burchfield, *Sultry August Afternoon*, Watercolor, 37 × 28″ (94 × 71 cm).
Private collection. Photograph courtesy Kennedy Galleries, New York.

An American artist, Charles Burchfield, created the painting shown in picture E. What idea or feeling did he express? What techniques did he use?

Use a sheet of paper for practice. See if you can discover some other painting techniques. Then paint a picture of an idea or feeling.

The Color Wheel

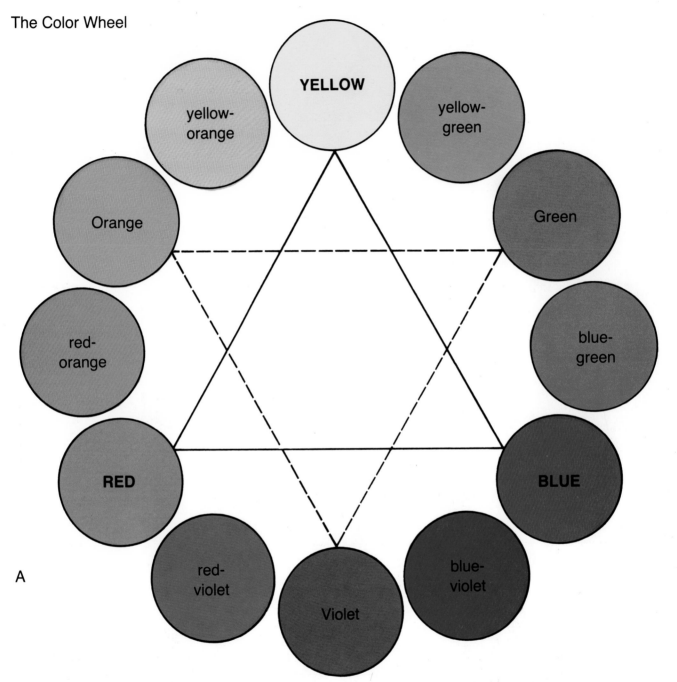

A

This color wheel will help you remember important ideas about mixing colors.

1. **Primary** colors are red, yellow and blue. You can mix other colors from them.

2. **Secondary** colors are orange, green and violet. These colors are created by mixing two primary colors.

3. **Intermediate** colors are yellow-orange, yellow-green, red-violet, red-orange, blue-violet and blue-green. All these can be mixed from primary colors.

4. Related colors are next to each other on the color wheel, such as blue, blue-violet and violet.

Practice mixing paint to create secondary and intermediate colors. Use three sheets of paper.

Begin each sheet with four circles of paint. Add dots of color to the circles.

B To mix the colors, brush the dots of paint so the colors blend together.

C

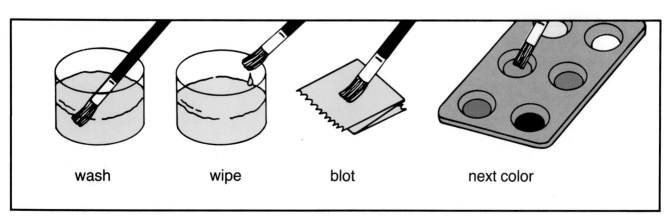

wash wipe blot next color

D Use your tempera paints this way. Do you know why?

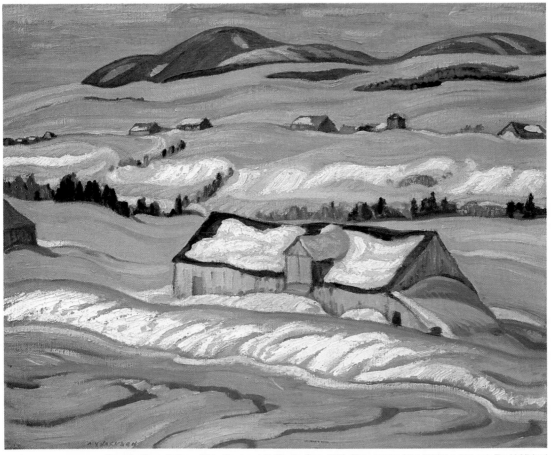

Alexander Young Jackson, *Winter Morning at St. Tite des Caps,* 1937. Oil on canvas, 21 × 30″ (54 × 66.5 cm). The McMichael
Canadian Collection, Ontario (Gift of Dr. R.W.I. Urquhart in memory of Helen C. Urquhart).

A

Artists use light and dark colors in their pictures. The lightness or darkness of a color is its **value**. Colors that have light values are **tints**.

This painting by A. Y. Jackson, a Canadian artist, has many light values. What tints did he use to show a winter morning? What colors did he use for shadows?

Learn to mix tints. Begin with white paint. Add dots of color. Mix the paint. What happens when you add more color to the white paint?

B
24

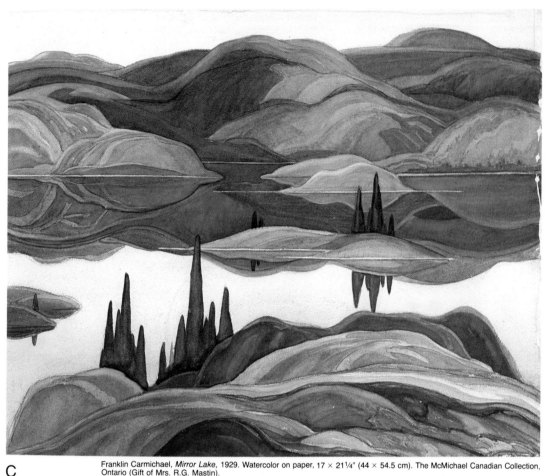

Franklin Carmichael, *Mirror Lake*, 1929. Watercolor on paper, 17 × 21¼″ (44 × 54.5 cm). The McMichael Canadian Collection, Ontario (Gift of Mrs. R.G. Mastin).

C

This painting is by another Canadian artist, Frank Carmichael. The painting has many dark values. Dark values of a color are **shades**.

A gradual change in values is called **shading**. A very great difference in values is called **contrast**. Contrast makes the parts of a painting easy to see.

Learn to mix shades. Begin with a color. Add dots of black to the color. Mix the paint. What happens when you add more black to the color?

D

Kinds of Artwork
Montage

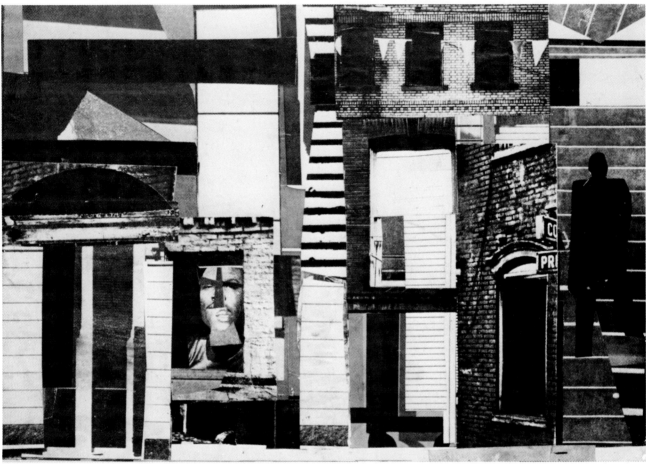

A

Romare Beardon, *Spring Way*, 1964. Courtesy the artist.

A **collage** is a picture made from cut or torn paper. The paper shapes are pasted on a background. Sometimes other shapes, lines or textures are added.

A **montage** is a special kind of collage. It is made from parts of magazine photographs or other pictures. The artist pastes the pictures together in a new way.

Romare Bearden's montage of a city street has shapes cut from many photographs. The shapes were pasted down to create a new picture.

The artist has created many montages about people who live in cities.

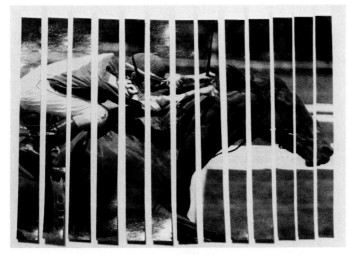

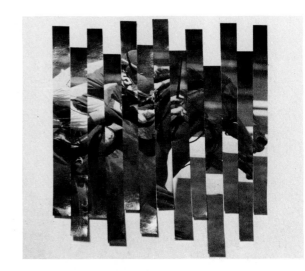

B

A montage can be made from one photograph. Cut the photo into curved or straight shapes. Move the shapes apart, or up and down.

A student created this montage from a large photograph of a mouth. The small picture of the astronaut was pasted on top of the large photograph.

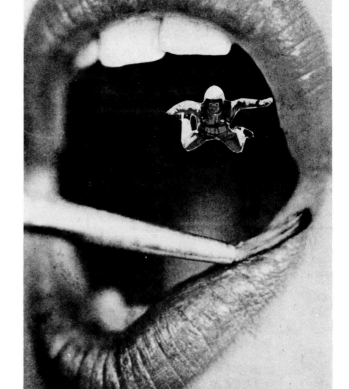

Look for pictures in old magazines or newspapers, and collect them.

Put your cut-out pictures on a piece of background paper. Move the pictures around. Try different arrangements. When you like your montage, paste the pictures down.

C

Photographs on this page from *The Art of Collage* by Gerald Brommer. Davis Publications, Inc.

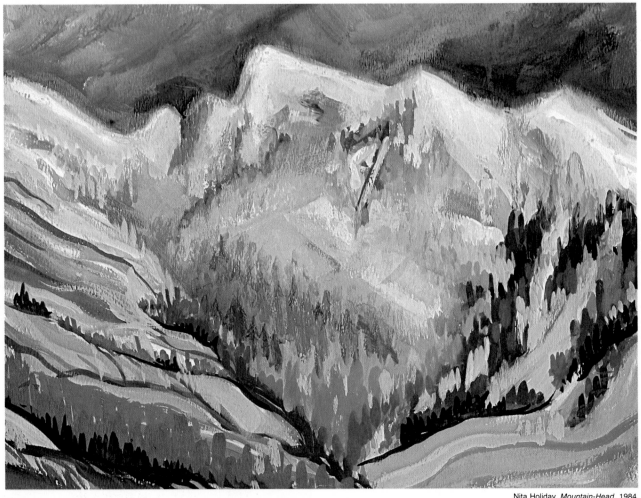

A

Nita Holiday, *Mountain-Head*, 1984.

Have you used your imagination lately? Look at these works of art. All of them have one thing in common. Can you tell what it is?

Do you see a strange landscape in this painting? Look again, but turn the picture so the left side is near you. Do you see a face?

This painting is an example of fantasy art. The artist has combined two very different ideas. They make one imaginary scene that you can see in two ways.

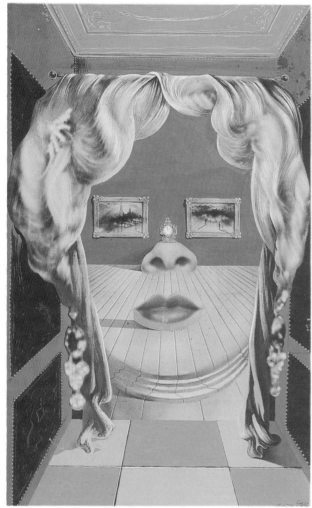

B Salvador Dali, *Mae West, ca.* 1934. Gouache, 10⅞ × 6⅞″ (28 × 17 cm). Art Institute of Chicago, Illinois (Gift of Gilbert W. Chapman).

Look at pictures B and C. Both are paintings by artists. What ideas did they combine in their paintings? What parts of each painting look unreal?

Picture D shows a sculpture that combines several very diifferent parts. Where have you seen examples of fantasy art?

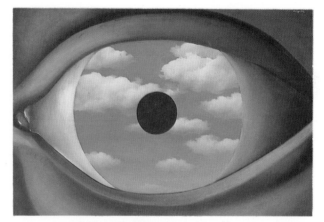

C Rene Magritte, *The False Mirror,* 1928. Oil on canvas, 21 1/4 × 31 7/8″ (54 × 81 cm). Collection, The Museum of Modern Art, New York (Purchase).

There are many kinds of fantasy art. All four of these pictures are double-images. One image is a face or part of a face. The other images are a landscape (A), a room (B), a sky (C) and a machine (D).

Think of some very different ideas that you could combine into one imaginary picture. Try to create a fantasy picture with a double image.

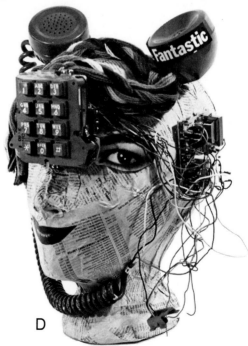

D

Bob Thomas from *Art Synectics* by Nicholas Roukes, 1982. Davis Publications, Inc., Worcester, Massachusetts.

Native American Art
Masks

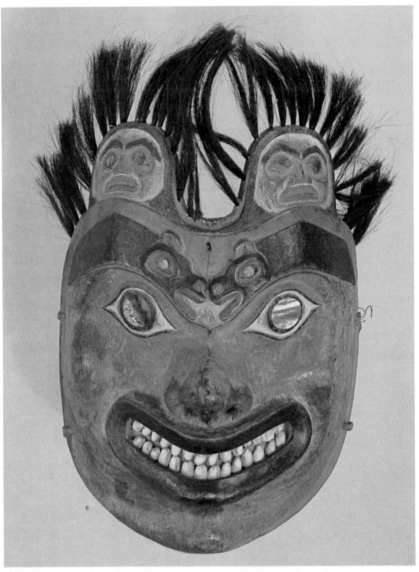

A

Mask (spirit of brown bear). Tlingit, Alaska, 1875, wood.

This mask was made long ago in Alaska. The people who made it admired the great strength of the brown bear. They believed that the mask would bring the spirit of the bear to them and make all the people strong.

This mask was carved from wood. Then it was painted. The design is symmetrical. **Symmetrical** means both sides of the mask are similar.

The masks in this lesson and the next were created by Native American artists.

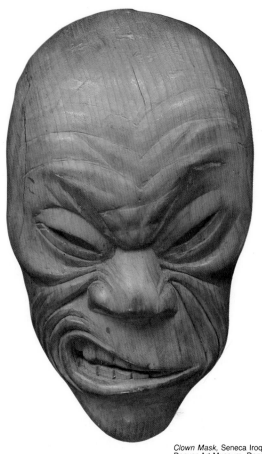

B

Clown Mask, Seneca Iroquois. Unpainted pine, string, 6½ × 9½″ (17 × 24 cm). Denver Art Museum, Denver, Colorado.

This Iroquois mask tells a story about a good spirit. The spirit has a broken nose and twisted mouth. The spirit helps people travel safely through the forest. The Iroquois people live in the eastern United States and Canada.

This mask is carved from wood. The design is **asymmetrical**. Each side of the mask is different.

You can create a mask from paper. You might fold paper and begin your mask as shown here.

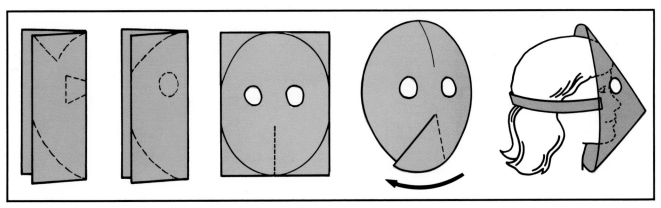

C

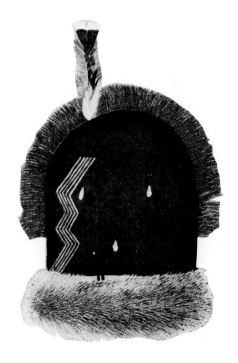

A *Navajo ceremonial mask.* Courtesy of the Library Services Department, American Museum of Natural History, New York.

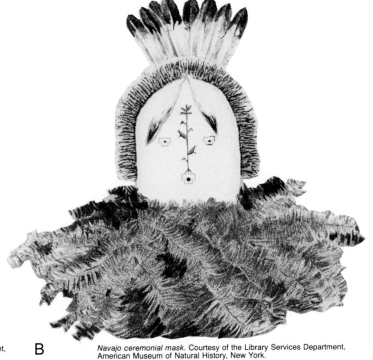

B *Navajo ceremonial mask.* Courtesy of the Library Services Department, American Museum of Natural History, New York.

Masks and costumes are one way people remember their traditions. Halloween is a tradition for many American children. It is a custom to have fun by dressing up in masks and costumes.

Masks A and B were created by Indians who live in the southwestern United States. Much of this region is a desert. The people need water to grow crops.

The two masks were made for special ceremonies in which people prayed for the rain spirit to come. The masks have symbols for lightning and corn. Can you explain why?

C How else could you add new parts to your mask?

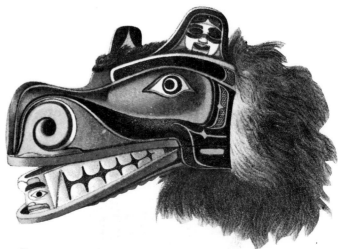

D
Mask of the Kwakiutl Indians of Vancouver Island, British Columbia.
Wood with movable parts. Courtesy of the Library Services Department,
American Museum of Natural History, New York.

Masks D and E were made by Indians who live in the great forests of Canada near the Pacific Ocean. They hunted animals and fished in the ocean.

These Indian people believed that animal spirits could make them strong and brave. They believed the masks could bring the animal spirits to help them.

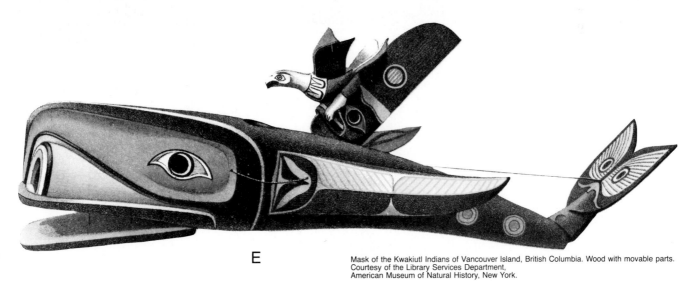

E
Mask of the Kwakiutl Indians of Vancouver Island, British Columbia. Wood with movable parts.
Courtesy of the Library Services Department,
American Museum of Natural History, New York.

These masks are no longer used. They are in museums where many people can see and study them. Some native Americans want to remember their traditions. At special times they still have ceremonies as their ancestors did.

Finish your mask. Try to add parts that make it three-dimensional. Three-dimensional art has height, width and depth. It is not flat.

15 Drawing Faces

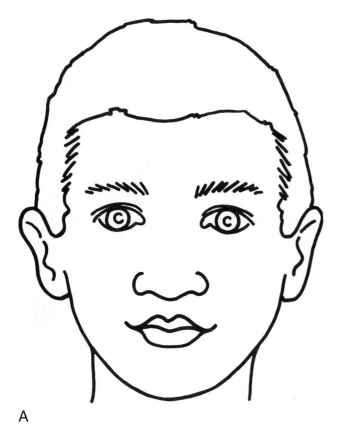

A

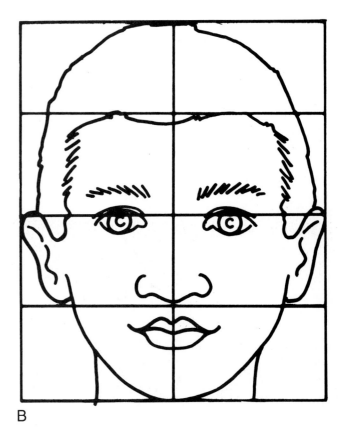

B

Today you will practice drawing faces. Artists learn to draw people by observing carefully. Faces, noses, eyes, lips and ears can be very different. Artists look for these differences.

Faces are also alike in many ways. The straight lines in picture B are guidelines for drawing the front view of a face. Sometimes artists use these guidelines.

These guidelines can help you draw:

1. the shape of the whole face
2. the eyes
3. the top and bottom of the nose and ears
4. the lips
5. the forehead and hairline

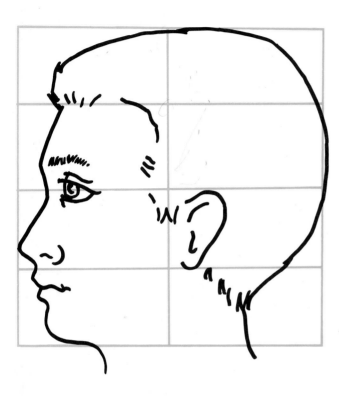

C

A side view of a face is called a **profile**. Sometimes artists draw guidelines before they draw a profile of a face. These guidelines can help you draw:

1. the shape of the whole face
2. the eyes
3. the top and bottom of the nose and ears
4. the lips
5. the forehead and hairline

Begin drawing with very light lines. Draw all the main parts of the face first. Then change the lines so your drawing is a portrait. A **portrait** is artwork that looks like a real person.

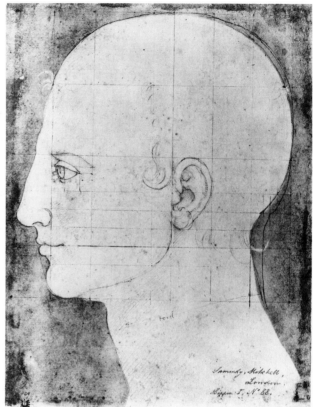

D

Albrecht Dürer, *Constructed Head of a Man in Profile.* Pierpont Morgan Library, New York.

This profile drawing was created by Albrecht Dürer. He was a famous artist who lived in Germany about 500 years ago. He drew the profile using guidelines.

Draw a front view or a profile of a face. Fold your paper and use the folds as guidelines.

E

Begin with a square sheet of paper to draw a profile.

Clay
Sculpture of a Head

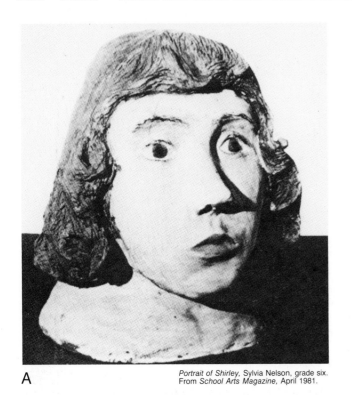

A

Portrait of Shirley, Sylvia Nelson, grade six. From *School Arts Magazine*, April 1981.

This portrait was made by a sixth-grade student. The student has learned to look at people very carefully. The student has also learned to make clay sculpture.

You will practice making a sculpture of a person. Study the pictures at the bottom of the page. Do you see how to begin?

1. Begin with an egg-shaped clay form. This will be the head. Make a thick cylinder for the neck. Trim the cylinder so the head will fit on it.

2. Press the parts together. The head and neck should look right from every side.

3. Draw guidelines to show where the main parts of the face will be located.

1

2

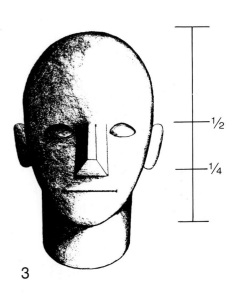

3

B

Carve and model the clay to make your sculpture. Build up the nose. Make the upper lip look different from the lower lip. Study the form of the eye and eyelids. Study your work from all sides.

Your guidelines will show the proportions in a typical human head. A **proportion** is the relationship between parts of something. Most people's eyes, for example, are about halfway between their chin and the top of their head. What other proportions can you describe?

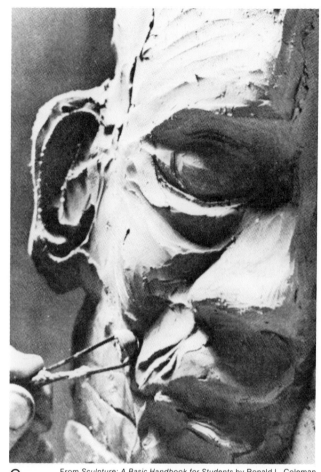

C

From *Sculpture: A Basic Handbook for Students* by Ronald L. Coleman. William C. Brown Publishers, Dubuque, Iowa.

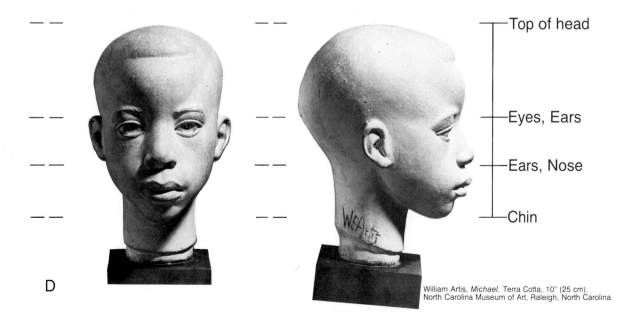

Top of head

Eyes, Ears

Ears, Nose

Chin

D

William Artis, *Michael*. Terra Cotta, 10″ (25 cm). North Carolina Museum of Art, Raleigh, North Carolina.

Art in Colonial Times
Portraits

Most of the pioneers who settled North America came from Europe. Some of the first settlers to create paintings were self-taught artists called **limners**.

As the first settlements grew into small towns and cities, artists from Europe came to America. They painted portraits for some of the wealthy colonists.

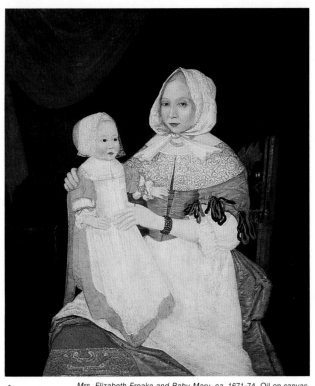

A *Mrs. Elizabeth Freake and Baby Mary, ca.* 1671-74. Oil on canvas, 42½ × 36¾" (108 × 93 cm). Worcester Art Museum, Worcester, Massachusetts (Gift of Mr. and Mrs. Albert W. Rice).

B Robert Feke, *James Bowdoin II*, 1748. Oil on canvas, 50 × 40" (127 × 102 cm). Bowdoin College Museum of Art, Brunswick, Maine (Bequest of Mrs. Sarah Bowdoin Dearborn).

A **limner** painted houses, furniture and signs. Some limners also painted portraits and landscapes. An unknown colonial limner painted this portrait.

In many early American portraits, the colonists are dressed up and posed to look like European aristocrats. Can you explain why?

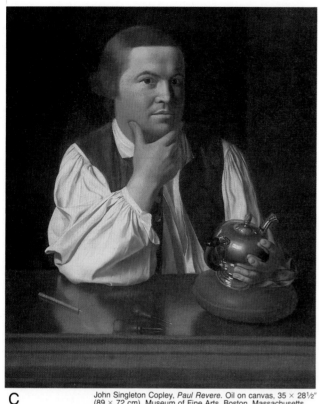

C John Singleton Copley, *Paul Revere.* Oil on canvas, 35 × 28½″ (89 × 72 cm). Museum of Fine Arts, Boston, Massachusetts (Gift of Joseph W., William B., and Edward H. R. Revere).

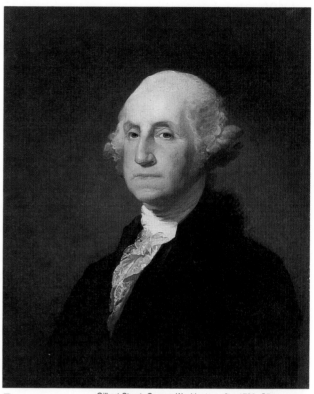

D Gilbert Stuart, *George Washington,* after 1796. Oil on canvas, 28¹⁵⁄₁₆ × 24¹⁄₁₆ (73.5 × 61.1 cm). Sterling and Francine Clark Art Institute, Williamstown, Massachusetts.

John Singleton Copley was the first American-born artist to become famous. He was born in Boston, Massachusetts. He painted this portrait of Paul Revere.

Paul Revere, like many colonists, was a skilled craftsworker. He designed and created the silver teapot shown in the portrait.

Gilbert Stuart also painted many portraits of famous Americans. He was born in Rhode Island. He is best known for painting this portrait of George Washington.

Before cameras were invented, all pictures were created by artists. Sometimes paintings and drawings from long ago help us know how people looked and lived in the past. Other kinds of artwork can help you learn about the past. Can you give some examples?

Art in the United States
A Family of Artists

Long ago, many American artists had to travel to Europe to study art. There were no American art schools for them to attend. Charles Willson Peale helped set up America's first museum and art school.

Some members of the Peale family are shown in this painting. Charles Willson Peale, the artist, is on the left bending down. He is watching his brother draw.

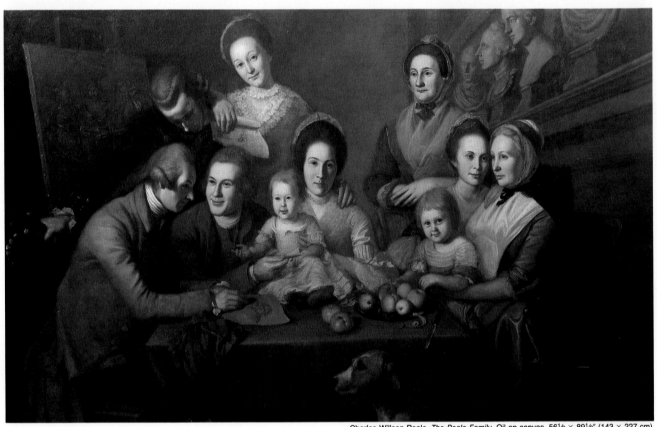

A

Charles Willson Peale, *The Peale Family*. Oil on canvas, 56½ × 89½" (143 × 227 cm). The New York Historical Society, New York.

Charles Willson Peale had three daughters who became artists: Anna, Margaretta and Sarah. Four of his sons also became artists. His sons were named for famous artists in Europe: Rubens, Rembrandt, Raphaelle and Titian.

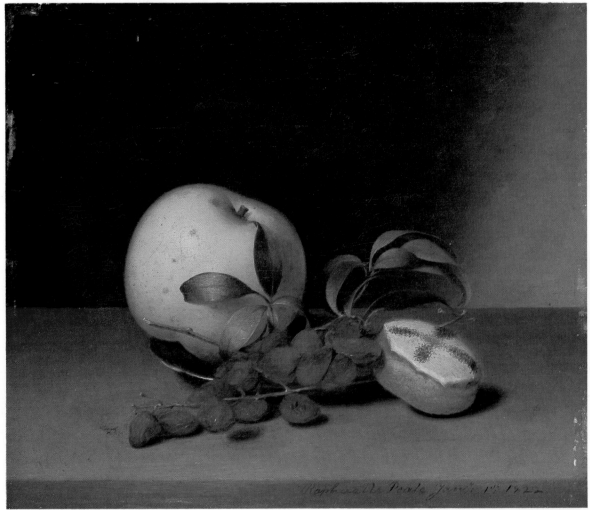

B

Raphaelle Peale, *Still-Life with Cake*. Brooklyn Museum, New York.

Raphaelle and Sarah Peale created these still life paintings. A **still life** is a picture of objects. Sometimes the objects are symbols. A book might be a symbol of wisdom, for example.

Draw a still life. Think of objects as symbols. What are some symbols for autumn or Thanksgiving? Could the objects in these still lifes be symbols? Why?

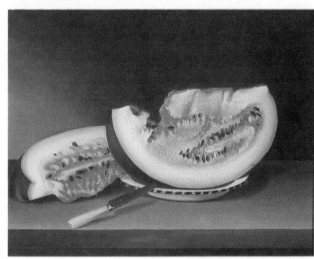

C

Sarah Peale, *A Slice of Watermelon*. The Wadsworth Atheneum, Hartford, Connecticut (Ella Gallup Sumner and Mary Catlin Sumner Collection).

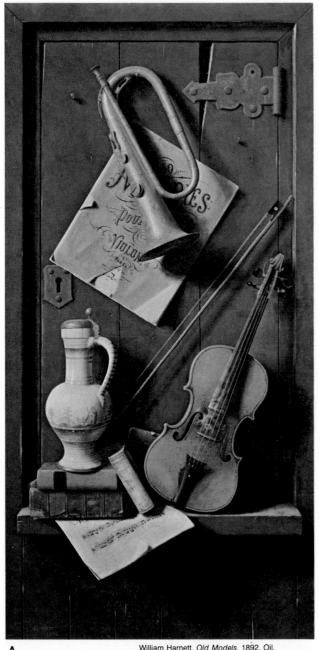

A William Harnett, *Old Models,* 1892. Oil,
The Museum of Fine Arts, Boston, Massachusetts.

William Harnett painted this still life about 100 years ago. The main subject is an old violin. What else do you see?

This style of art is one kind of **realism**. The artist has used paint to create colors, textures and shapes that look real.

B Henry Lee McFee, *Still Life,* 1916. Oil on canvas, 20 × 16″ (51 × 41 cm).
Columbus Museum of Art, Ohio (Gift of Ferdinand Howald).

Henry Lee McFee created this painting about 70 years ago. The main subjects are books and fruit in a glass bowl.

This style of art is called **cubism**. Notice how the artist used patches of paint to create shapes. The colors are not blended together. In some cubist paintings, the colors of paint look like cubes and other geometric forms.

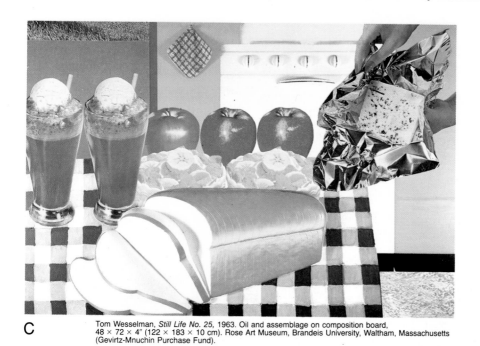

C Tom Wesselman, *Still Life No. 25*, 1963. Oil and assemblage on composition board, 48 × 72 × 4″ (122 × 183 × 10 cm). Rose Art Museum, Brandeis University, Waltham, Massachusetts (Gevirtz-Mnuchin Purchase Fund).

Tom Wesselman created this painting about 25 years ago. This style of painting is **pop art**. "Pop" is a short word for popular. Pop art usually tells about things you see in advertisements and stores.

Paint your drawing of a still life. Paint it in your own style. The steps in picture D will help you learn to paint efficiently. An efficient artist works quickly and thoughtfully.

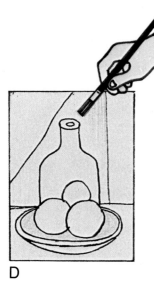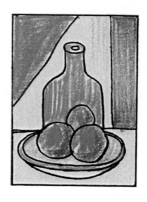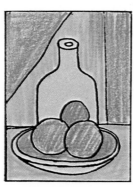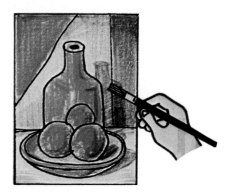

D

Paint the large areas first. Use a big brush.

If shapes are the same color, paint them next.

Add light, dark and related colors.

Use a small brush to add details.

Artists know that hands can express feelings and ideas. Study the hands and arms in this painting.

Do the hands look weak or strong? Do the fists make you think the person is angry or sad?

This painting is called *The Sob*. Could you have guessed the title? This painting was created by the famous Mexican artist, David Siqueiros.

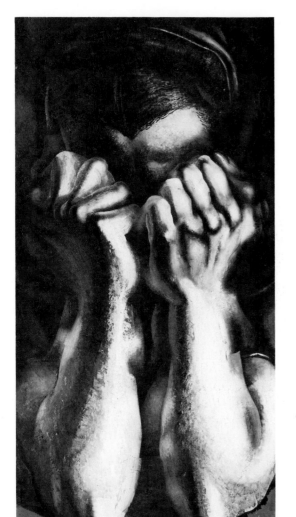

A David Alfaro Siqueiros, *The Sob,* 1939. Duco on composition board, 48 1/2 × 24 3/4" (123 × 63 cm). Collection, The Museum of Modern Art, New York (Given anonymously).

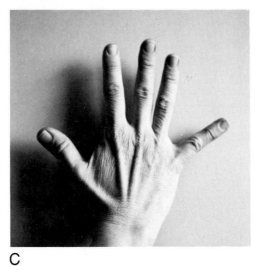

C

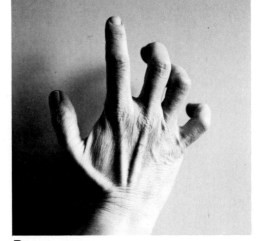

D

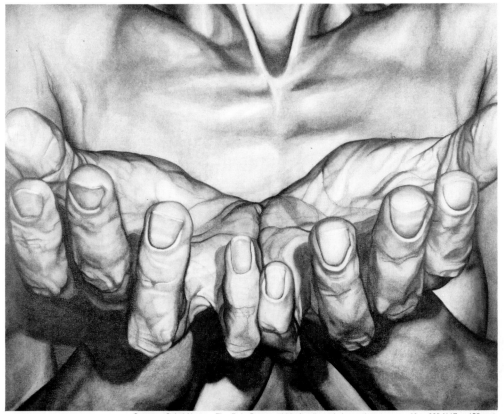

B
Sassona Sakel Norton, *The Rain Prayer,* 1982. Acrylic and charcoal on canvas, 46 × 60″ (117 × 152 cm). Sutton Gallery, New York.

Hands can be the most important part of a work of art. This painting, by Sassona Norton, is very big. It is 46 x 60″ (117 x 152 cm). Why do you think the artist made this painting so large? What do the hands seem to be saying?

Look at the four photographs of hands. They show different views and positions of hands.

Draw a picture of hands. Try to draw hands that express a feeling or idea.

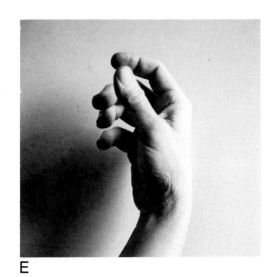

E

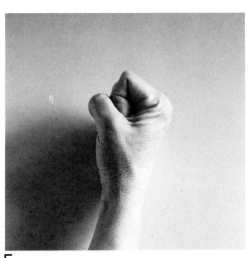

F

About 150 years ago, the western part of America was being explored and settled.

Some of the first artists to travel westward created pictures of the frontier.

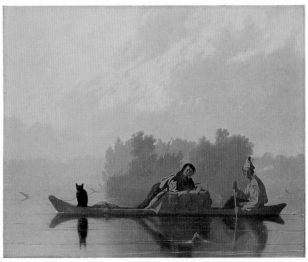

George Caleb Bingham painted pictures about the people who explored and settled by the great rivers—the Mississippi, Missouri and Ohio.

A George Caleb Bingham, *Fur Traders Descending the Missouri.* Oil on canvas, 36½ × 29″ (93 × 74 cm). The Metropolitan Museum of Art, New York. (Morris K. Jesup Fund, 1933).

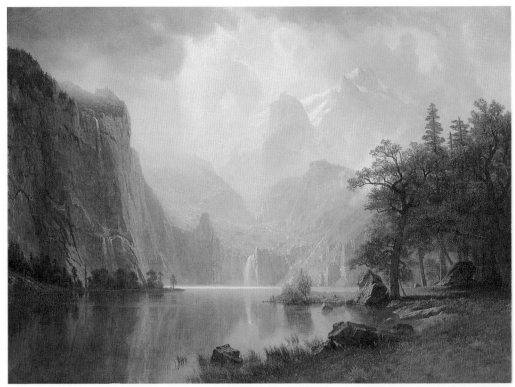

B Albert Bierstadt, *In the Mountains.* The Wadsworth Atheneum, Hartford, Connecticut.

Albert Bierstadt traveled to the Rocky Mountains. He made sketches and small paintings. When he returned to his home in New York, he created larger paintings of scenes he remembered.

Between 1800 and 1900, people began to build towns and cities in many parts of America. Some artists wanted to make pictures of frontier life before it vanished.

Frederick Remington and Charles Russell traveled west and worked as cowboys for part of their lives. Both artists became famous for their paintings and sculptures about cowboys and Indians.

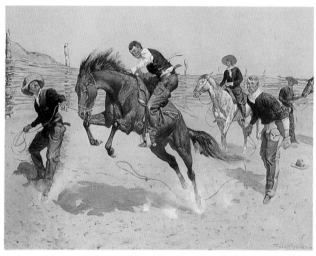

C Frederic Remington, *Turn Him Loose, Bill*. 25 × 33″ (63 × 84 cm). Kennedy Galleries, New York.

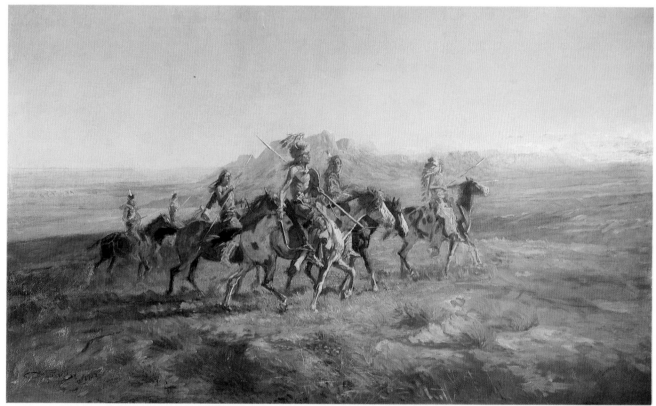

D Charles M. Russell, *Sun River War Party*. Oil on canvas, 17¾ × 29¾″ (45 × 76 cm). The Rockwell Museum, Corning, New York.

Suppose that you can create a work of art that people will see 100 years from now. Think about special places or events that you would like those future people to know about. Create a picture about the places or events.

Much of America's wilderness was explored or settled between 1800 and 1900. Around 1900, cities began to grow larger and more crowded.

Many artists chose to paint pictures about life in the city. George Bellows was one of many artists who created art about the city.

Look at his painting, *Cliff Dwellers*. What does the title mean? What parts of the painting make the whole scene look crowded?

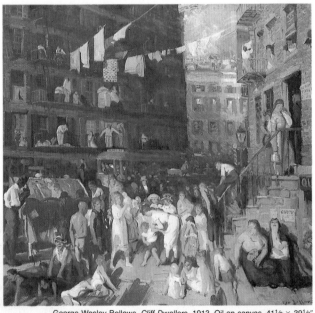

A

George Wesley Bellows, *Cliff Dwellers*, 1913. Oil on canvas, 41½ × 39½" (105 × 100 cm). Los Angeles County Museum of Art, California (Los Angeles County Funds).

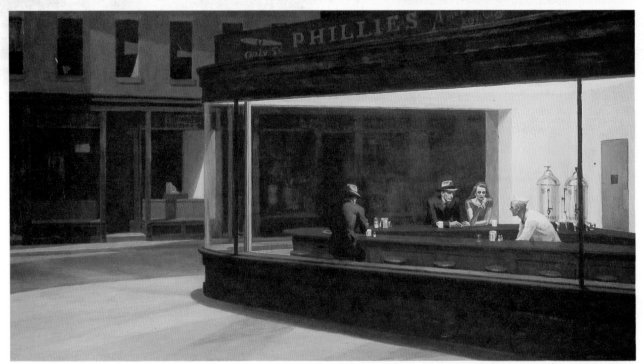

B

Edward Hopper, *Nighthawks*, 1942. Oil on canvas, 33⅛ × 60" (84 × 152 cm). The Art Institute of Chicago, Illinois (Friends of American Art Collection).

What feelings do you get when you look at Edward Hopper's *Nighthawks*? Try to explain why the painting gives you those feelings.

Many of Edward Hopper's paintings show the city when it is very quiet and still. In some paintings, there are no people or just a few.

C Max Weber, *Rush Hour, New York,* 1915. Canvas, 36¼ × 30¼″ (92 × 77 cm). National Gallery of Art, Washington, D.C. (Gift of the Avalon Foundation 1970).

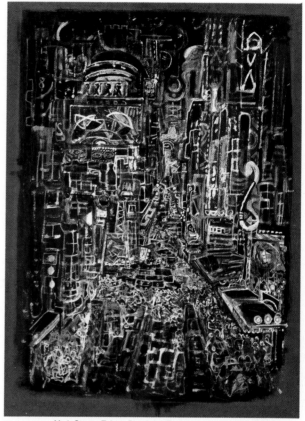

D Mark George Tobey, *Broadway.* Tempera on composition board, 19⁹⁄₁₆ × 26″ (49 × 66 cm). The Metropolitan Museum of Art, New York (Arthur Hoppock Hearn Fund, 1942).

Many people in cities go to and from work at about the same time every day. This time is often called "rush hour." During rush hour, people are in a hurry to get to work or to get home.

Max Weber's painting is titled *Rush Hour, New York.* What lines, shapes and colors did he use to express the feeling of rush hour in a big city?

Look at Mark Tobey's painting, *Broadway.* Broadway is a street in New York City. The street has many large signs that flash on and off at night. There are many theaters and movie houses with bright lights. The streets are crowded with people, cars and buses.

What lines, shapes and colors express the idea and feeling of Broadway at night?

What ideas and feelings do you get when you think about life in a big city?

Think of an original picture you could draw about life in a big city.

49

Originality in Art
Creating Your Own Artwork

All five of the pictures in this lesson have the same subject. The pictures show the Brooklyn Bridge, in New York City. Two of the pictures are photographs. Three are paintings.

All of the pictures are different. Each artist has seen and thought about the bridge in a special way. They have created original artwork about the same subject.

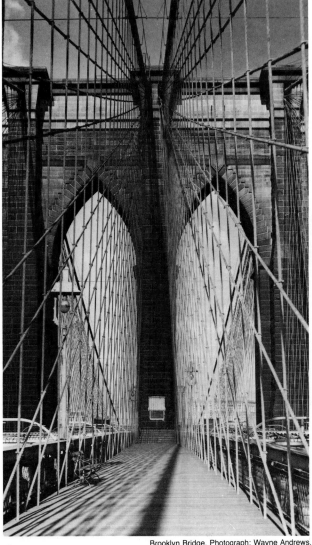

A

Brooklyn Bridge. Photograph: Wayne Andrews.

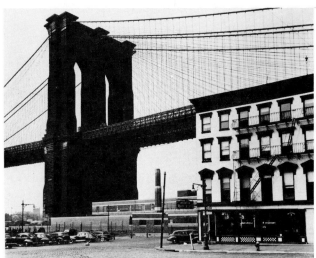

B

Brett Weston, *Brooklyn Bridge.*

The Brooklyn Bridge was designed by John Roebling more than 100 years ago. Many artists have created pictures about the bridge. Why do you think artists have been so interested in this subject?

Notice the different views of the bridge. What else makes each picture different from the others?

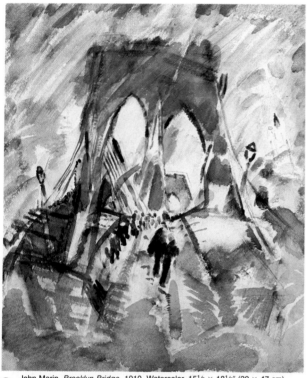

C John Marin, *Brooklyn Bridge,* 1910. Watercolor, 15½ × 18½″ (39 × 47 cm). The Metropolitan Museum of Art, New York (The Alfred Stieglitz Collection, 1949).

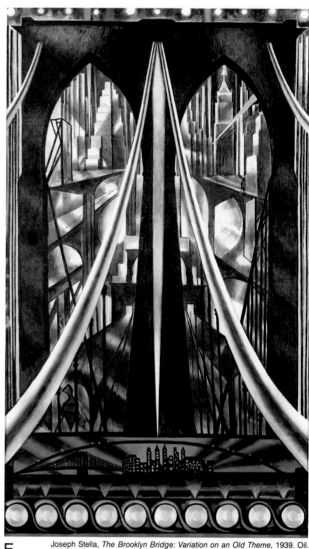

E Joseph Stella, *The Brooklyn Bridge: Variation on an Old Theme,* 1939. Oil. Whitney Museum of American Art, New York.

Today everyone in your class will draw the same subject. Think of some ways you can make an original picture of the same subject.

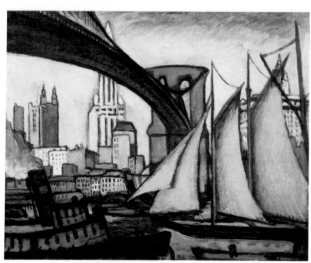

D Samuel Halpern, *Brooklyn Bridge,* 1913. Oil, 34 × 42″ (86 × 107 cm). The Whitney Museum of American Art, New York.

An architect made these drawings of houses. He wanted to teach people about some of the styles of houses created in America's history.

Study the roofs, chimneys, doors and windows. Look for similarities and differences. Have you seen houses similar to any of these?

Imagine you could design a dream house of your own. Draw a picture that shows how the front might look.

1620 Frame house with thatched roof, stick and mud chimney.

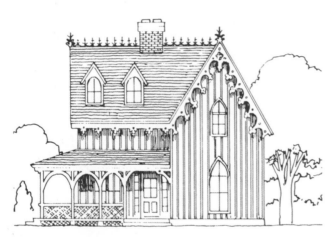

1830 Gothic house with many pointed arches.

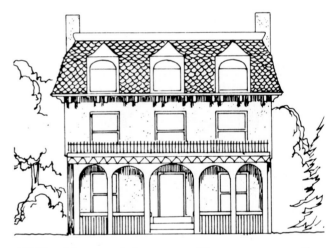

1855 Mansard house with rooms on the third floor.

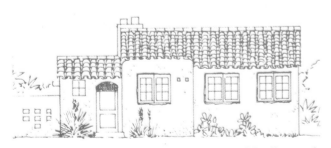

1920 California Mission house with tile roof.

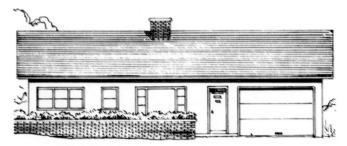

1950 Ranch house with large picture window in front.

Drawings from *Environmental Interiors* by Weale, Croake and Weale. Macmillan, 1982. Used by permission, Mary Jo Weale and Tim J. Bookout.

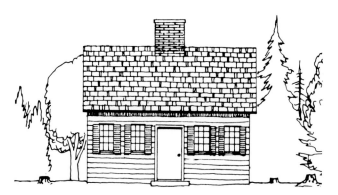

1690 Cape Cod house with one chimney for the entire house.

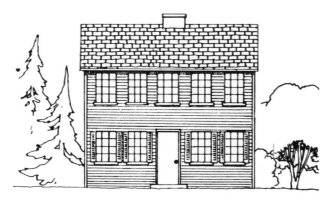

1770 Salt-box house with two stories, attic, one chimney.

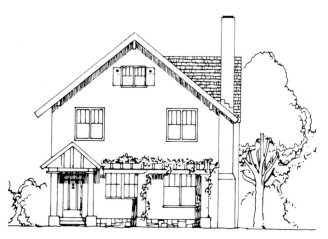

1900 The Craftsman house with concrete on the front.

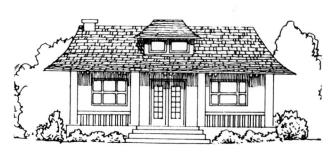

1905 Bungalow with wood shingle roof.

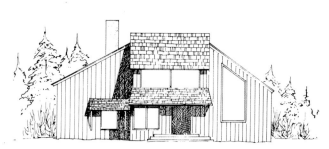

1970 Modern house with windows of different sizes and shapes, stained wood finish.

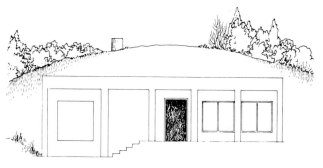

1980 Energy-saving house set in a hill to help keep the house cool in summer and warm in winter.

25

Fiber Arts
Quilting

In Colonial times, people saved every good scrap of fabric. Many scraps were used to make quilts. Quilts are a kind of handmade blanket.

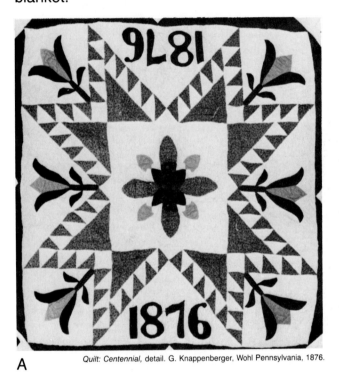

A

Quilt: Centennial, detail. G. Knappenberger, Wohl Pennsylvania, 1876.

In Colonial times, quilting was often a group activity. Neighbors helped each other make quilts. Boys and girls helped sew quilts.

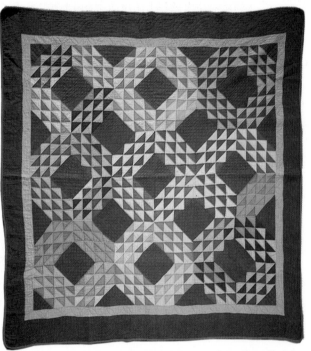

B

Quilt: Ocean Waves Pattern, Mrs. Raber, Honeyville, Indiana, *ca.* 1930. Museum of American Folk Art, New York.

This is one small part of an old quilt. The pieces of fabric were stitched together carefully to create the radial design.

A quilt has three layers. The top and bottom layers are cloth. The middle layer usually is a cotton padding. The three layers are sewn together so the stitches make a design.

The Amish people settled in the eastern part of America. They still create beautiful quilts.

This quilt was designed from many small squares and triangles of fabric.

Today, some people hang quilts on walls, just like a painting. Many art museums display beautiful old and new quilts.

You can practice the art of quilting. Use your own cloth design.

1. Fold your cloth. Put padding inside.

2. Tape or pin the edges.

3. Sew through all three layers. Use a running stitch to outline your shapes.

4. Finish the edge.

D

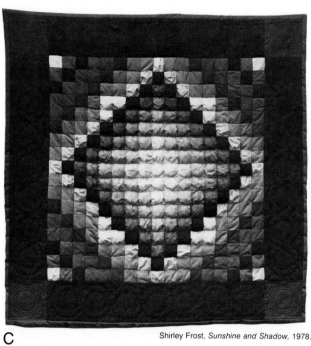

C

Shirley Frost, *Sunshine and Shadow*, 1978.

This modern quilt looks like a soft sculpture. It has extra padding.

Quilting is a very old craft. Today it is one of many fiber arts. Some other fiber arts are weaving, stitchery or sewing, and a special kind of knotting called macramé.

26

Crafts
Art Made by Hand

Some artists are called craftsworkers. **Craftsworkers** create objects from leather, metal, wood, glass and other materials. Sometimes craftsworkers are called **artisans**.

Craftsworkers design objects and create them one at a time. Everything is carefully made by hand.

Craftsworkers learn to create objects with great skill. A well-crafted object can be a work of art. Many museums have collections of beautifully made objects.

Paul Revere, a famous American patriot, created this silver pitcher more than 180 years ago.

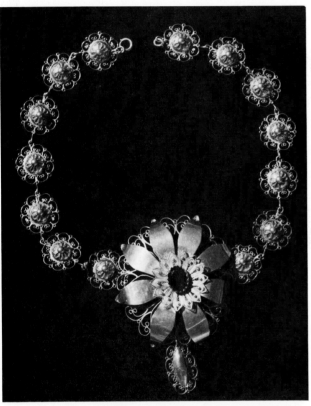

A

Gold Filigree Necklace. New Mexico, first half of 19th century. Museum of New Mexico.

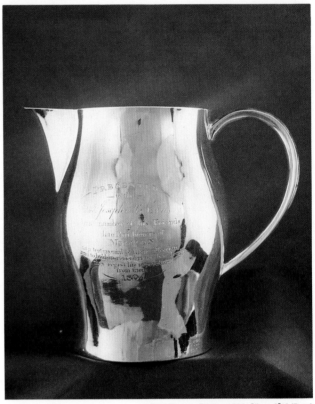

B

Paul Revere, *Pitcher*, 1804. Silver, 6⅝″ (7 cm).

This gold Mexican necklace was created about 160 years ago. The craftsworker was an expert in creating objects from metal.

This pitcher was made from a flat sheet of metal. The metal was shaped by hand, with a hammer. The handle was made in the same way.

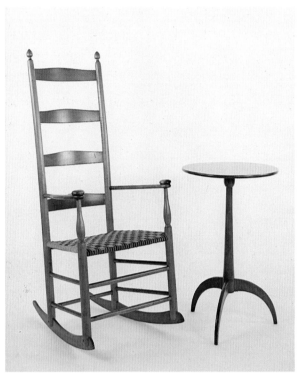

C

Candlestand and Chair, Shaker. 25¼" and 44" (64 × 112 cm).

These are examples of handmade Shaker furniture. The Shaker people were a religious group that came to America more than 200 years ago.

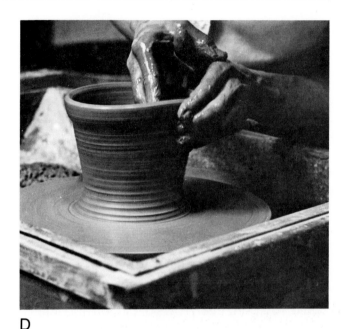

D

This artisan is shaping a pot from clay. Have you ever watched people create hand-made objects? Do you like to create crafts? How are handcrafted objects different from objects made in factories?

Finish your small quilt. Try to create a well-crafted object.

Printmaking
Surface Designs

Large sheets of fabric, gift paper and wallpaper often have surface designs. Artists create these designs which are then printed by machines. Some artists also print fabrics or papers by hand. This is how surface designs were printed long ago.

This wallpaper was handmade more than 150 years ago. Part of the design was carved in a block of wood. The block was then covered with thick ink. The design was printed over and over again on long sheets of paper.

Imagine you printed this wallpaper. How could you print even rows of circles and lines?

A Wallpaper, ca. 1820, from Guilford, Connecticut. Courtesy of the Cooper—Hewitt Museum, Smithsonian Institution/Art Resource, New York.

E

1. Press the clay down very firmly on an object. At the same time, make a strong, thick "handle" for the stamp.

2. Remove the objects. Make the grooves deep. Deep grooves stay unclogged and clear even with repeated use.

58

You can learn to create a surface design. Design and print some large sheets of paper to wrap gifts.

Design your own printing stamp. These surface designs were made with a small clay printing stamp.

B

C

D

Plan the shape of your printing stamp and the design on the bottom of the stamp. Print your surface design many different ways.

3. Add paint to printing pad as needed.

4. For clear prints, press gently, count to five, then lift the stamp.

Architecture
Making a Model Building

Architects are artists who plan buildings. They plan the forms you see on the outside of a building. They also plan the spaces inside a building.

Many architects plan buildings which have forms such as these. The space inside the forms is used for rooms. Have you seen buildings that have forms like these?

These forms have curved edges.

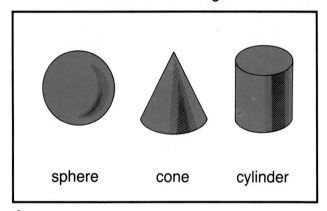

sphere cone cylinder

A

These forms have straight edges.

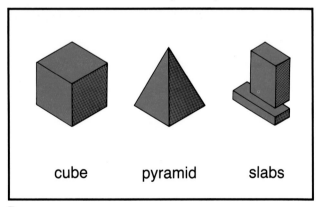

cube pyramid slabs

B

You can find many kinds of buildings in North America. Some of the oldest buildings have forms that help us remember how North America was settled.

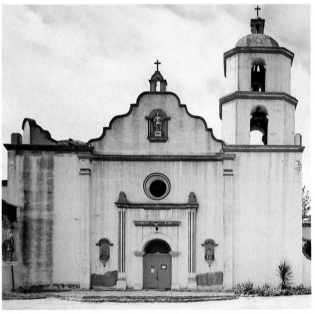

C

Padre Antonio Peyri, *San Luis Rey Mission*, California.

Early settlers from Spain built forts, churches and schools. The curved edges and bell towers of this church are like some buildings in Spain.

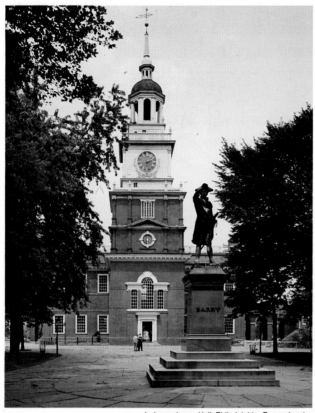

D *Independence Hall*, Philadelphia, Pennsylvania.

E St. Paul Street, Montreal, Canada. Courtesy Blackader-Lauterman Library, McGill University, Montreal.

Settlers from England also brought their ideas about buildings to the New World. Independence Hall in Philadelphia has forms like those of famous buildings in England.

People who came from Holland, Sweden and other lands also brought their ideas about buildings to North America. Are some of the buildings in your town like those in other lands? Why?

This building in Montreal, Canada, has forms like those of buildings in France. Can you explain why?

Sometimes architects create models to plan the forms of buildings. The small model helps them imagine how the real building might look.

You can construct a model of a building. Begin by gluing or taping some forms together.

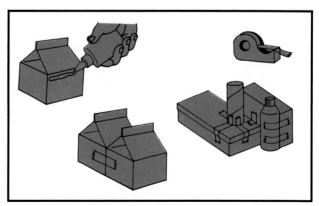

F What kind of building will you design?

Architecture
Ideas about Architecture

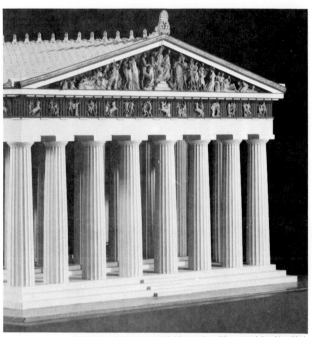

Parthenon. Restored model. Metropolitan Museum of Art, New York.

A

The people who settled America brought ideas from many lands. Some of their ideas about laws, government and art came from ancient Greece and Rome.

Many buildings in Europe and America have forms like those in ancient Greek and Roman buildings.

This is a model of the Parthenon, a building constructed about 2,400 years ago in Greece.

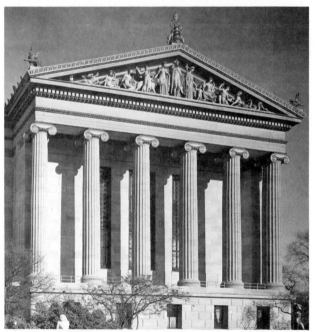

East Pediment of the Exterior of the Philadelphia Museum of Art.
Photograph: Eric Mitchell, 1980. Philadelphia Museum of Art, Pennsylvania.

B

This building was constructed about 40 years ago. It is part of the Philadelphia Museum of Art. How is it like the Parthenon? How is it different?

There are similar buildings in many large cities in North America. Can you explain why?

This is a model of the Pantheon, a building constructed more than 1,800 years ago in Rome, Italy.

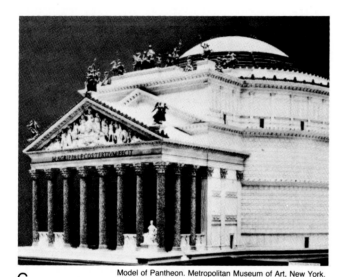

C

Model of Pantheon. Metropolitan Museum of Art, New York.

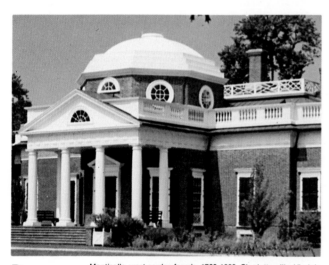

D

Monticello, west garden facade, 1768-1809. Charlottesville, Virginia.

Thomas Jefferson, an American president, was also an architect. He designed this building at the University of Virginia. How is it like the Pantheon? How is it different?

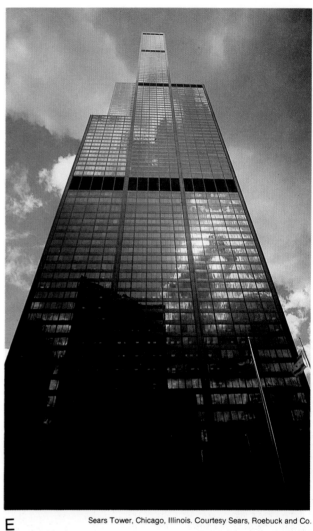

E

Sears Tower, Chicago, Illinois. Courtesy Sears, Roebuck and Co.

Some architects design new kinds of buildings. This skyscraper in Chicago was built in 1974. It has 110 stories. It has a "skeleton" of steel and a "skin" of glass.

Paint your model of a building. While the paint is drying, cut some paper shapes for windows and doors. What other details could you add? How can you make them?

Do you know some people who create art? What kind of art do they make?

Creating art can be fun, but it is also a kind of work. Some kinds of art can only be made by very hard labor.

This artist is creating a sculpture by welding together pieces of steel. Have you ever seen the blue-white flame of a welding torch? This kind of artwork takes imagination, practice and patience to create.

Look at the painting shown in picture B. Winslow Homer painted it when he was eleven years old. He studied art in school and later became famous for his artwork.

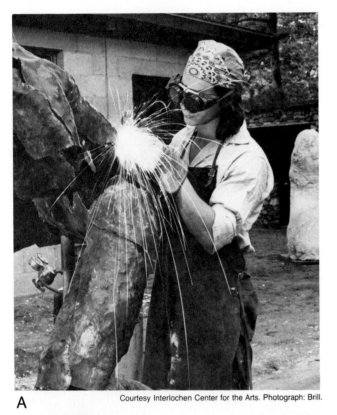

A Courtesy Interlochen Center for the Arts. Photograph: Brill.

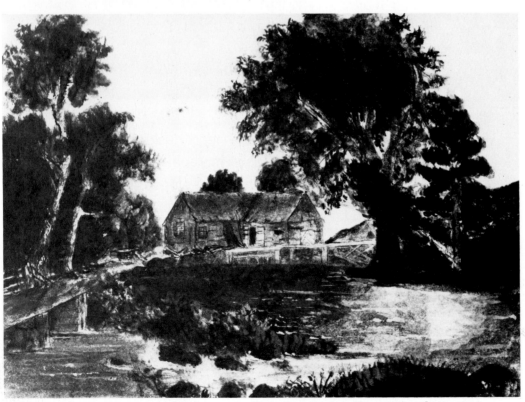

B Winslow Homer, *Farmhouse*. Watercolor, 3½ × 4⅞" (9 × 12 cm). Bowdoin College Museum of Art, Brunswick, Maine (Gift of the Homer family).

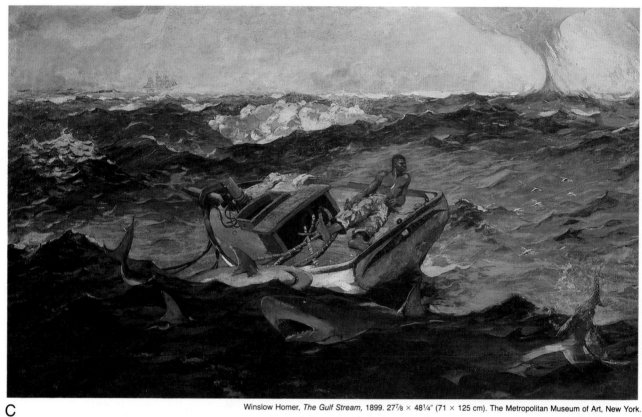

C

Winslow Homer, *The Gulf Stream*, 1899. 27⅞ × 48¼″ (71 × 125 cm). The Metropolitan Museum of Art, New York.

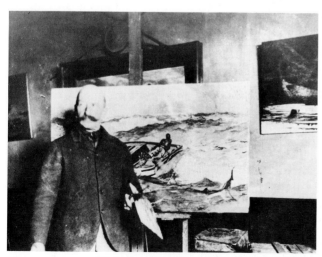

D

Winslow Homer in his studio with his painting *The Gulf Stream*. Bowdoin College Museum of Art, Brunswick, Maine.

Picture C shows a painting Winslow Homer did as an adult.

Picture D shows Winslow Homer in his studio. A **studio** is a place where an artist works. The artist holds a palette for mixing his paints. His painting, *Gulf Stream*, is on an easel.

Look at some of the artwork you have created this year. Try to complete any unfinished artwork. Try to improve some of the artwork you have created.

Review
Looking at Art

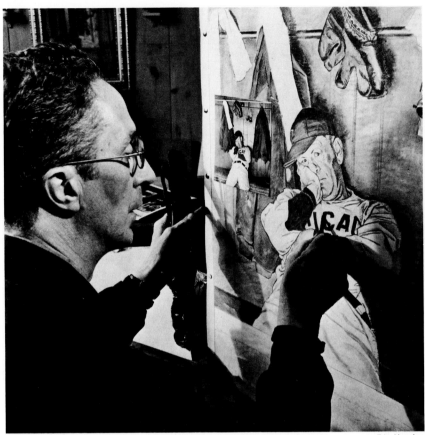

Courtesy Fritz Henning.

A

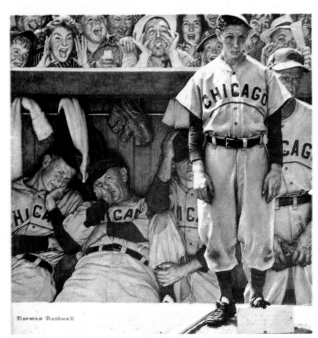

B Norman Rockwell, *Dugout*. Reprinted from *The Saturday Evening Post* © 1943
The Curtis Publishing Company.

Norman Rockwell was one of America's most famous illustrators. An illustrator is an artist who creates pictures that explain something or tell a story.

Picture A shows Norman Rockwell at work in his studio. He is creating a sketch for a magazine cover. The finished artwork for the magazine is shown in picture B. What story idea does the illustration show? How did the artist help you guess the feelings of the players and the crowd?

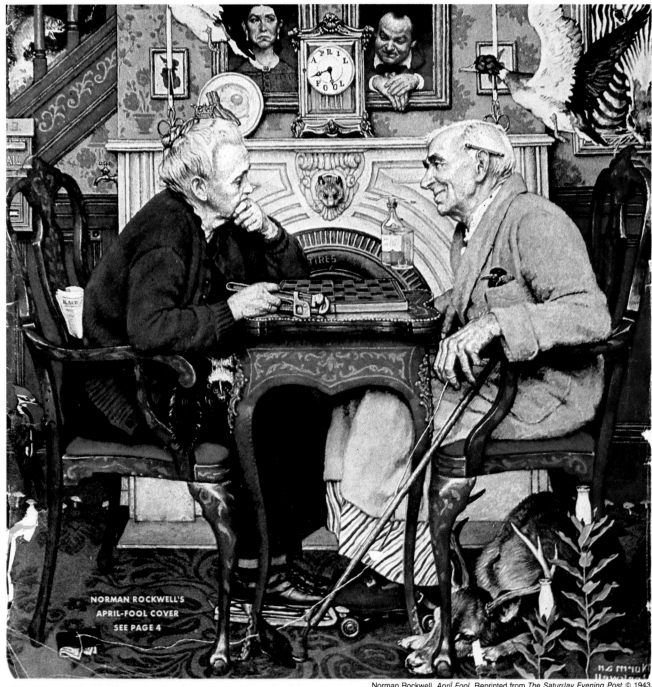

Norman Rockwell, *April Fool*. Reprinted from *The Saturday Evening Post* © 1943 The Curtis Publishing Company.

C

Norman Rockwell created this illustration, too. The picture was designed for a magazine that people could buy on April Fool's Day.

This illustration is like a puzzle. It is filled with strange details. List as many strange details as you can find.

Choosing What to See
Drawing

Artists learn to look at things in many different ways. They often choose to look at details within a larger scene.

Look at the photograph of a telephone pole in picture A. What do you see? Can you find the transformer that is shown in detail in picture B?

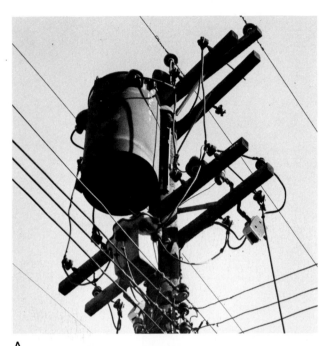

A

You can see and draw one scene in many ways. Look at the examples of artwork on the next page. All of the art ideas came from the photograph in picture A. Look for differences in the drawings.

Find a scene to draw. Draw it in several ways. Look for something different to show in each drawing of that scene.

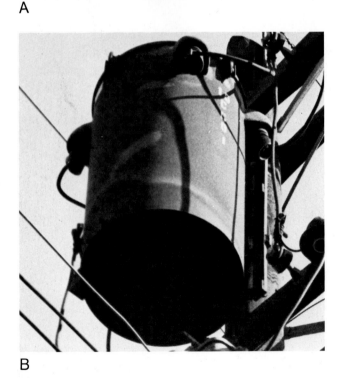

B

C

This drawing shows the edges or contours of the telephone pole.

D

This drawing shows everything very black or very white.

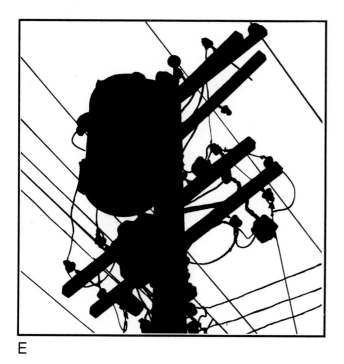

E

This drawing shows all the forms in black.

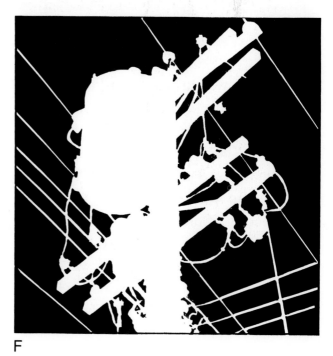

F

This drawing shows all the forms in white.

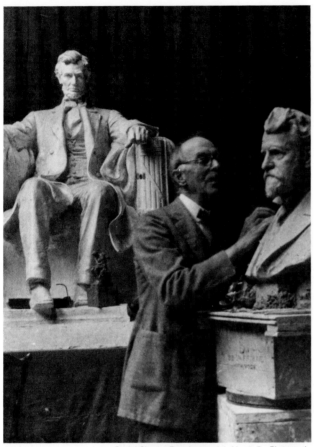

A

Daniel Chester French at work in his studio. Photograph.
Chesterwood, Stockbridge, Massachusetts.

B

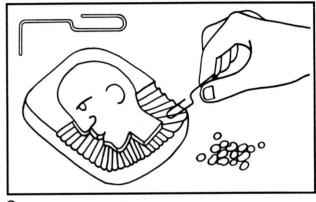

C

Art offers a way to learn about famous people. All of the pictures in this lesson are portraits of Abraham Lincoln, one of America's presidents. These portraits are sculptures.

The photograph in picture A shows a model of a sculpture in Washington D.C. for the Lincoln Memorial. Daniel Chester French, a famous American sculptor, made the model. The photograph shows him at work on a sculpture in his studio. Daniel Chester French also created the statue of Lincoln shown in picture F on the next page.

The Lincoln coin in picture B is an example of relief sculpture. In a **relief sculpture**, parts stand out from a flat surface. You could carve a relief sculpture from a flat slab of clay.

A portrait **bust** is a sculpture of the head and chest of a person. The bust in picture D was carved by Edmonia Lewis. She created many sculptures from white marble. Marble is a kind of stone.

A **statue** is a sculpture that shows a person's whole body. Augustus Saint-Gaudens created the statue of Lincoln shown in picture E. Augustus Saint-Gaudens also became a famous artist. His studio in Cornish, New Hampshire, is a national historic site.

Create a clay sculpture. You might try to show someone you admire. Will you create a statue, a portrait bust or a relief sculpture?

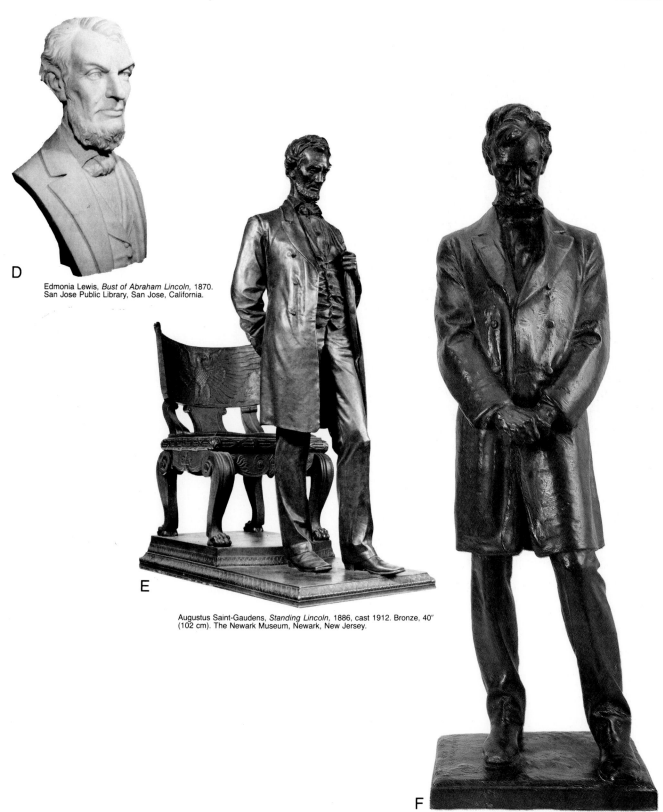

D

Edmonia Lewis, *Bust of Abraham Lincoln,* 1870.
San Jose Public Library, San Jose, California.

E

Augustus Saint-Gaudens, *Standing Lincoln,* 1886, cast 1912. Bronze, 40″
(102 cm). The Newark Museum, Newark, New Jersey.

F

Daniel Chester French, *Standing Lincoln,* 1912.
Bronze, 38″ (97 cm).
Whitney Museum of American Art, New York.

71

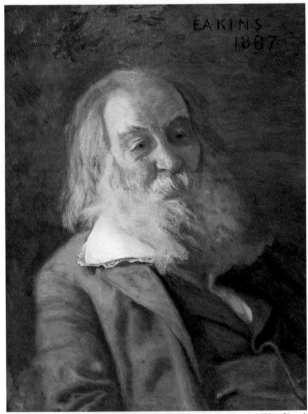

A Thomas Eakins, *Walt Whitman*, 1887. Oil on canvas, 30 × 24″ (76 × 61 cm). The Pennsylvania Academy of The Fine Arts, Philadelphia (General Fund Purchase).

Portraits of famous people can be studied in many ways. You might enjoy looking at a portrait to remember why the person became famous.

You can also look at portraits as artwork. You can think about the way the artist has shown the person. You can study the lines, shapes, colors and textures the artist created.

Imagine you were Thomas Eakins (say AKE-ins), the artist who painted the portrait of Walt Whitman in picture A. What are some decisions the artist made when he painted the portrait?

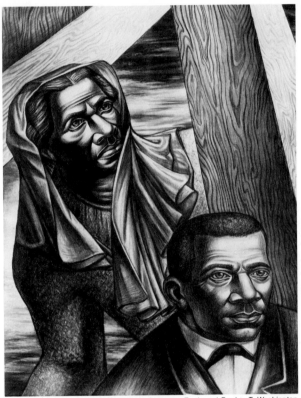

B Charles White, *Sojourner Truth and Booker T. Washington*. The Newark Museum, Newark, New Jersey.

Charles White created this pencil drawing. What parts of the drawing are shaded? How did he show the texture of wood? What else did the artist want you to see in these portraits of Booker T. Washington and Sojourner Truth?

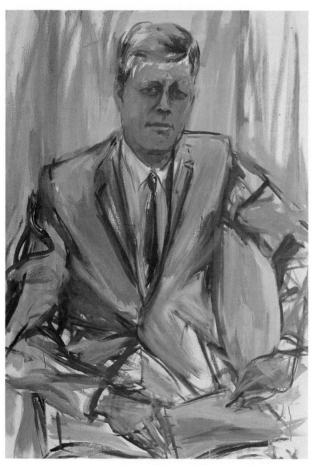

C

Elaine de Kooning, *Portrait of President John F. Kennedy,*
1962-63. Oil on canvas, 61 × 46″ (155 × 117 cm).
The Harry S Truman Library, Independence, Missouri.

Portraits have been painted of all of the presidents of the United States. This portrait was created by Elaine De Kooning. First she made sketches of President John F. Kennedy. Then she created this painting.

Portraits of famous people often can be found on postage stamps, coins and paper money. Can you explain why?

D

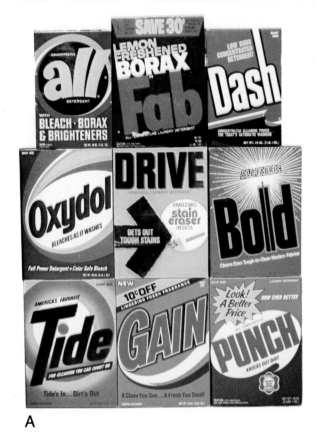

A

Look at the designs for laundry soap boxes. Most of them have bright colors and one large word that you see first.

Artists called **graphic designers** created these designs. They planned the lettering, the lines, the colors and all the shapes on the package.

B

Look at the large shapes behind the bold letters. Find the package with a large arrow and circle. Do you think these shapes go with the name of the soap?

C

D

E

F

Look at pictures C, D, E and F. Find the packages with similar lines and shapes. Why do you think so many packages have swirling curves or circles?

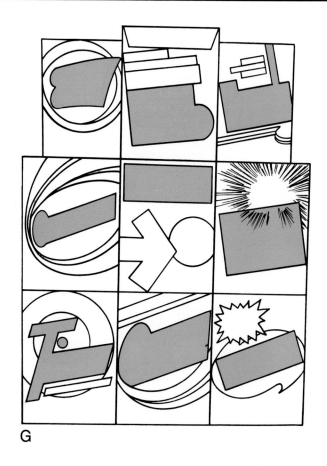

G

Look at picture G. The shaded parts are similar to the large letters on each soap box.

Most of the brand names on the soap packages are slanted upward and have very large letters. The diagonal lines give most people a feeling of action or motion.

What other things do you notice in these designs for soap boxes? Why are soap names and box designs so carefully planned?

The designs on these boxes of salt have been changed about five times in the last 80 years. Why do you think the designs were changed?

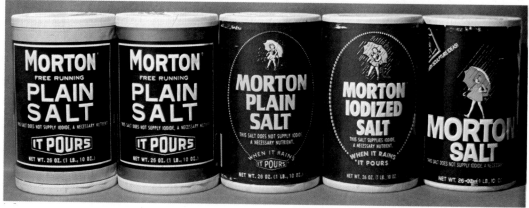

H

Imagine you are a graphic designer for a cereal company. Draw a design for the front of a new cereal box.

Living with Art
Changes in Designs

1900–1920

A

1920–1940

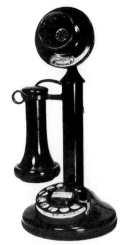

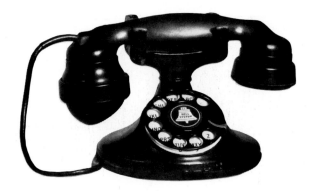

Courtesy American Telephone and Telegraph Company.

B

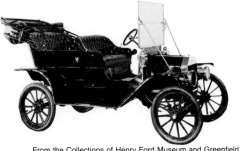

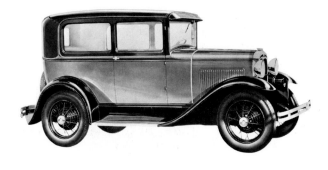

From the Collections of Henry Ford Museum and Greenfield Village.

C

The symbols in row A are examples of graphic design. A graphic designer plans the lettering and artwork that you see in books, magazines, advertisements and many other forms of communication.

The designs in row A are called logos. A **logo** is a symbol for a company or an organization. What changes do you see in the design of these logos? Why do you think the designs have changed since 1900?

1940–1960

1960–present

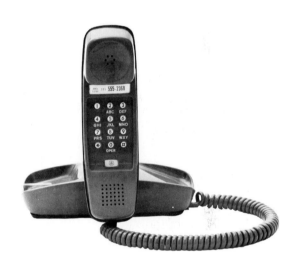

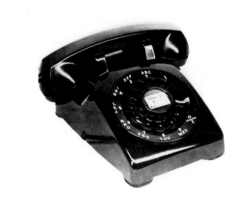

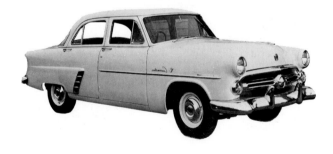

The telephones and cars are examples of **product design**. A product or industrial designer is an artist who plans the forms, shapes, lines, colors and textures of factory-made products.

What changes can you see in the telephones and cars? Why do you think the designs have changed since 1900?

Today, people have many choices in the designs for a single product. Look through some newspapers or magazines for pictures of automobiles, chairs, lamps and other products. Cut out the pictures and display them. Find out why people like some designs more than other designs.

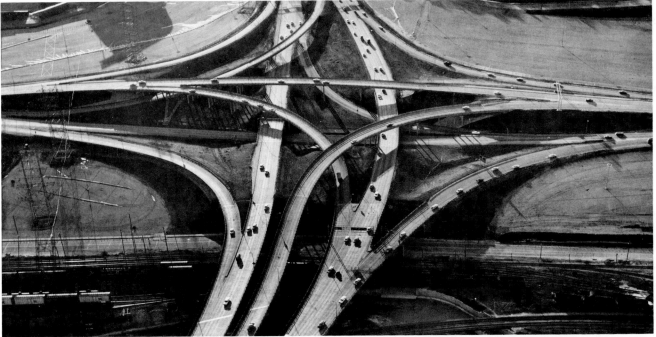

A

Photograph: Claire J. Wilson.

An artist took this photograph of roads. The lines of the roads go over and under each other. They curve and merge, making paths for the movement of cars.

An artist created this painting of lines. The lines create paths of movement for your eyes to follow. Can you see and feel a rhythm in the movement?

B

Frank Stella, *Protractor Variation*, 1969. Fluorescent-alkyd on canvas, 20 × 10′ (6 × 3 m). The Los Angeles County Museum of Art (Museum Associates Acquisitions Fund).

A rhythmic motion is created by repeating similar lines over and over again.

The wavy, horizontal lines in this photograph of water help you to feel that the water is moving. The lines go up and down, back and forth in a rhythmic motion.

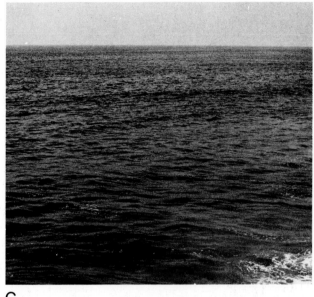

C

An artist created this drawing of waves. He invented lines to show the rhythmic movement of waves. How is his drawing similar to the photograph of waves? How is it different?

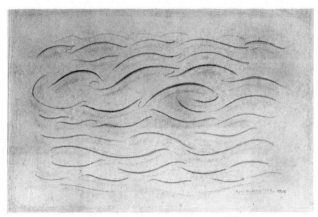

D Abraham Walkowitz, *Wave Abstraction*, 1912. Pencil, 10½ × 16″ (27 × 41 cm). Museum of Fine Arts, Boston, Massachusetts.

Does this drawing of water give you a feeling of rhythmic movement? Did the artist draw the top of water or the streams underneath that a fish might see?

You can hear rhythms in music. You can move your body to rhythm. You can see rhythmic movements, too. Try to draw a picture with visual rhythms.

E Paul Klee, *Play on Water*, 1935. Pencil, 7 × 10⁹⁄₁₆″ (18 × 27 cm). Paul Klee Foundation, Museum of Fine Arts, Bern, Switzerland.

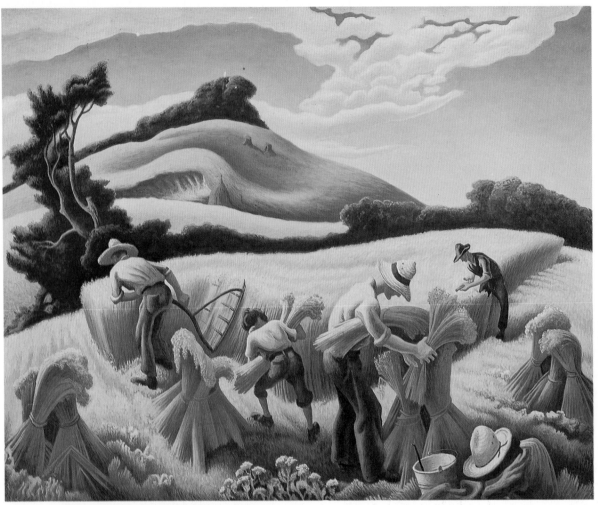

A Thomas Hart Benton, *Cradling Wheat*, 1938. Tempera and oil on board, 30¹¹⁄₁₆ × 37⅝" (78.7 × 96.5 cm). The St. Louis Art Museum, St. Louis, Missouri.

There are different kinds of rhythm in music and in dance. You can also find different kinds of visual rhythms in art.

This painting was created by Thomas Hart Benton, an American artist from Missouri. The painting shows people harvesting wheat. Do you see the visual rhythms?

Visual rhythms here are created by curves. Can you find some repeated curves? What ideas or feelings do the curved rhythms help to express?

B

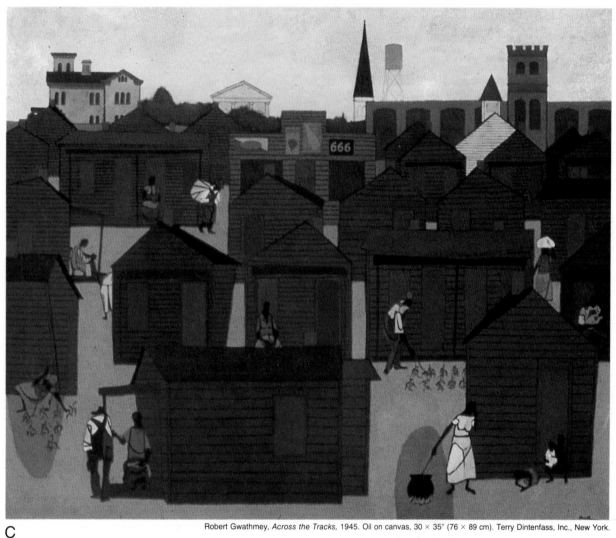

C

Robert Gwathmey, *Across the Tracks,* 1945. Oil on canvas, 30 × 35″ (76 × 89 cm). Terry Dintenfass, Inc., New York.

This painting was created by Robert Gwathmey, an American artist. The painting shows the houses of poor people who live near a city. Look for visual rhythms in the painting.

These visual rhythms are created by straight lines and shapes. What lines and shapes are repeated? Can you explain why?

Draw a picture with a special visual rhythm. What ideas or feelings will you try to express?

D

Drawing
Action in Landscapes

In the artworks pictured here, four American artists have used lines and shapes to suggest action, energy and motion.

John Marin suggests action by drawing diagonal lines that thrust in different directions. What other elements help you see and feel the energy of a large city?

Rockwell Kent suggests motion by repeating curved lines and shapes. What else helps you feel the churning energy and action of the sea?

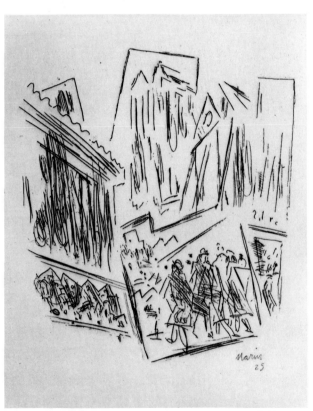

A John Marin, *Downtown, New York, Three Movements*, 1925. Etching, 8⁷/₁₆ × 6¹¹/₁₆″ (21 × 17 cm). The Philadelphia Museum of Art, Pennsylvania.

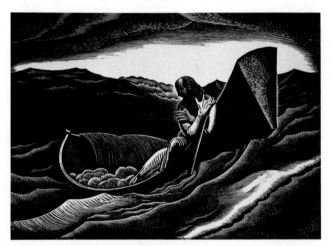

B Rockwell Kent, *The End*, 1927. Wood engraving 4⁷/₈ × 7″ (12 × 18 cm). The Philadelphia Museum of Art, Pennsylvania (Gift of Gordon A. Bloch, Jr.).

All of these pictures are art prints, made from printing blocks. A printing block allows the artist to make many copies of the picture.

The art prints by Thomas Hart Benton and John Steuart Curry have large arrow-like shapes that suggest motion. What other lines and shapes suggest action or energy?

Draw a landscape or seascape that suggests action, motion and energy. In the next lesson, you will use your drawing to make an art print.

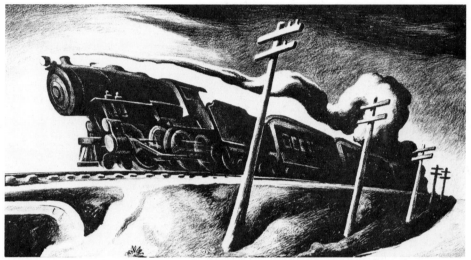

C

Thomas Hart Benton, *Going West*, 1929. Lithograph, 12⁵⁄₁₆ × 23³⁄₈″ (31 × 59 cm). The Philadelphia Museum of Art, Pennsylvania (Given anonymously).

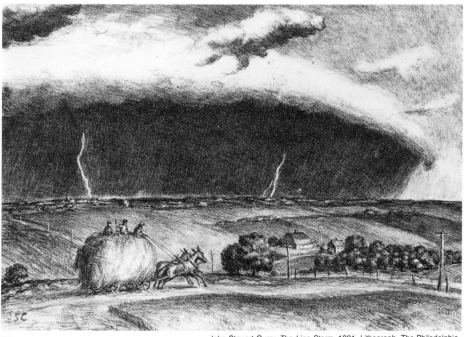

D

John Steuart Curry, *The Line Storm*, 1891. Lithograph. The Philadelphia Museum of Art, Pennsylvania (The Harrison Fund).

Printmaking
Action in Relief Prints

You can make an art print of your landscape or seascape. Printing is a way to make many copies of a picture.

Some prints are made by carving a picture in a block of wood. The artist puts thick ink on the block and presses paper against the block. This kind of print is called a **woodcut**.

A Lyonel Feininger, *Yacht Race.* 10½ × 5¹¹⁄₁₆″ (27 × 14 cm). The Norton Simon Museum of Art at Pasadena, California (Galka E. Scheyer Blue Four Collection).

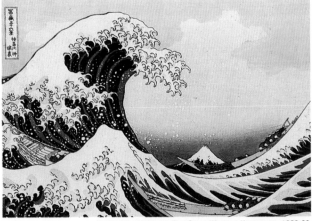

B Katsushika Hokusai, *The Great Wave at Kanagawa,* 1823-29. The Metropolitan Museum of Art, New York (The Howard Mansfield Collection, Rogers Fund, 1936).

Look at picture A. How were the white and the black shapes made in this print? How did the artist show action and motion?

The woodcut shown in picture B was created by a Japanese artist. How are pictures A and B alike? How are they different?

You can make some prints. Press your design into a block of Styrofoam. Then follow these steps.

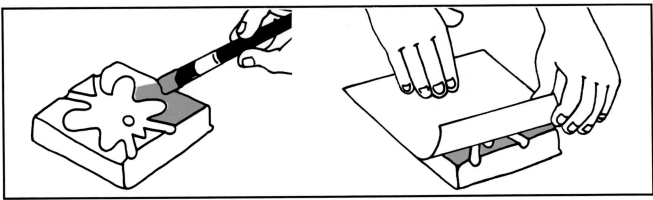

E 1. Put paint or ink on your block.

2. Place paper on top of the block.

You will make your print from a block of Styrofoam. Put your drawing on the Styrofoam and re-draw the lines. As you draw, you will press thin lines into the block.

Remove your drawing. Press your pencil into the traced lines in the Styrofoam. Your lines should look as if they are carved into the block.

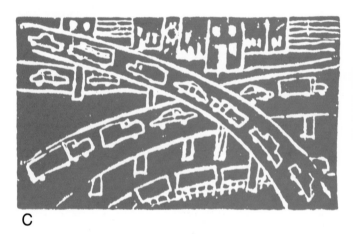

C

This Styrofoam print was made by a fifth grade student. She made this print by putting ink on her Styrofoam carving.

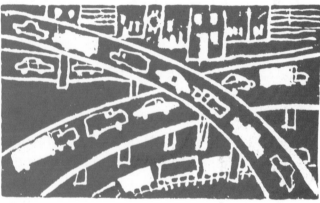

D

Study your first prints. You may want to change parts of your block. Can you find the changes in this print? How were they made?

Put your name and a title on your prints. Keep and mount the best ones.

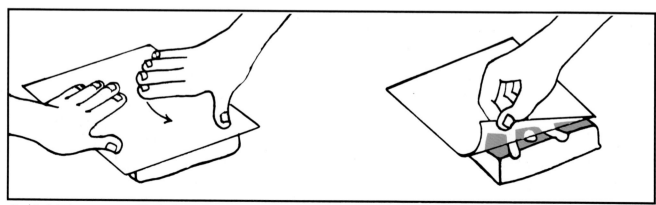

3. Hold the paper. Rub it all over.

4. Lift the paper. Let your paint dry.

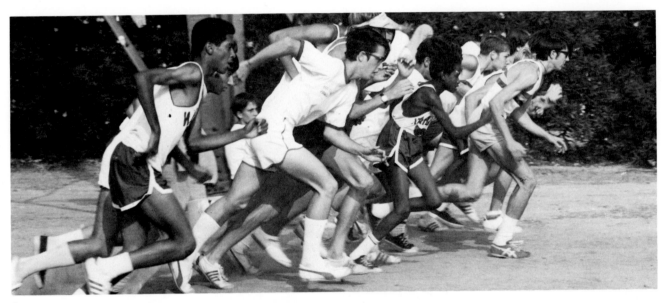

A

Artists learn to look for lines that show the action and movement of people. Action lines often bend just as parts of your body can bend. Look at the diagonal lines of these runners. They lean forward at the start of the race.

What lines show the action and movement of the ballet dancers in picture B? What parts of your body bend or stretch when you run, dance or play?

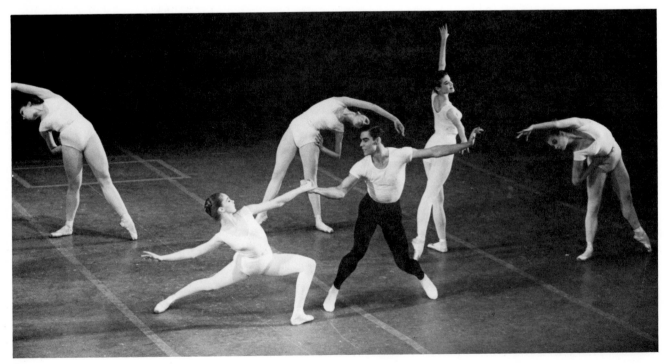

B

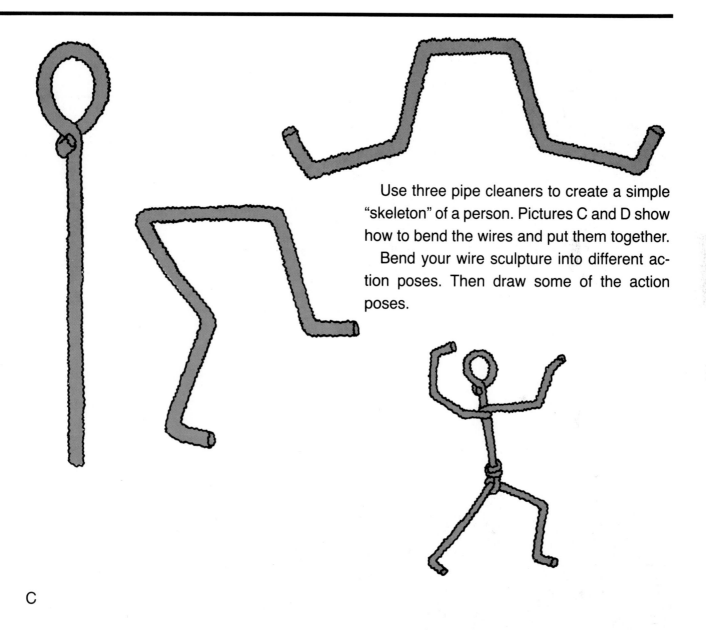

Use three pipe cleaners to create a simple "skeleton" of a person. Pictures C and D show how to bend the wires and put them together.

Bend your wire sculpture into different action poses. Then draw some of the action poses.

C

D

42

Drawing
Crowds

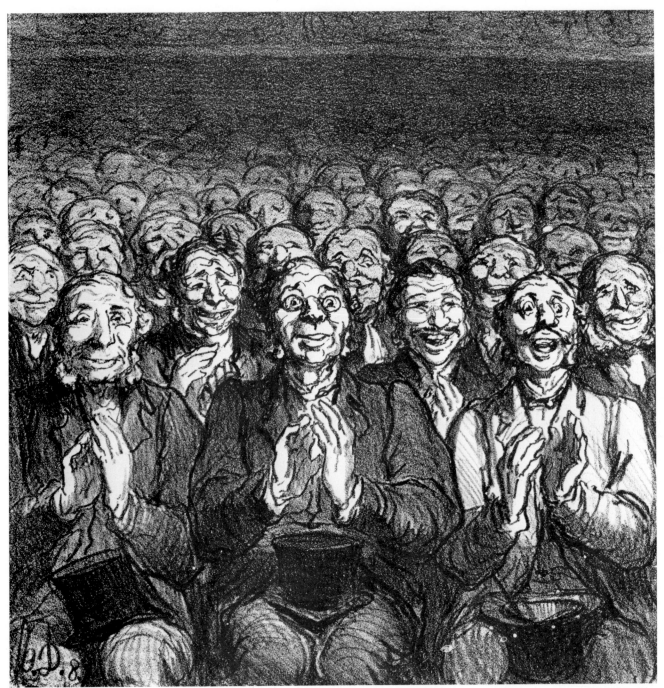

A

Honoré Daumier, *They Say the Parisians Are Hard to Please.* Lithograph. Museum of Fine Arts, Boston, Massachusetts (Bequest of William P. Babcock).

Honoré Daumier created this drawing more than 100 years ago in France. He created many drawings that are like editorial cartoons in newspapers. How did the artist draw this crowd?

What parts of Daumier's picture might have been drawn first? How could he quickly draw each row of people? Are the heads of all the people the same size? Why or why not?

You can learn to draw crowds quickly, just as artists learn to do.

Draw several people quite large, near the bottom of your paper. Those figures will be in the **foreground** of your picture.

Now draw other people behind the first ones you drew. Draw them smaller and above the first people you drew.

Add more people in the same way. All of the people in the **background** should be drawn smaller. Can you explain why?

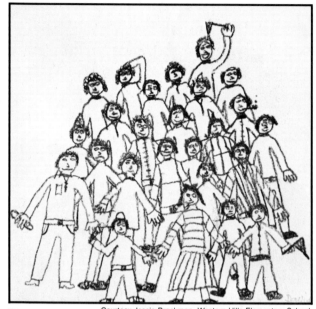

B

Courtesy Jessie Brockman, Western Hills Elementary School, Fort Worth, Texas.

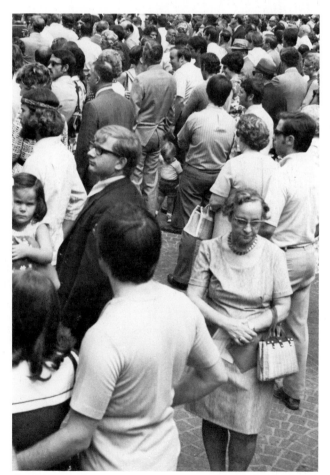

Draw a picture of a crowd. You might draw a parade, a party or people watching a ball game. Where else do you see crowds of people? Could you draw crowds of animals, trees and other kinds of things?

C

Clay
Sculptures of People

These sculptures were made by three different artists. The artists have shown people sitting down, with their arms and legs bent. The person in each sculpture seems to be thinking about something.

Look at the hands and feet in each sculpture. Look at the knees and elbows. Do you ever sit in positions like these?

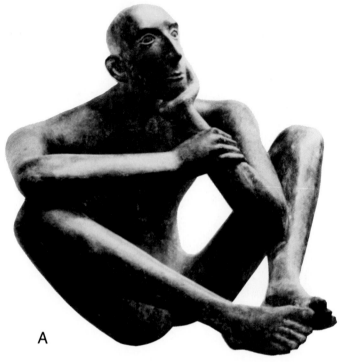

A

Karl-Heinz Krause, *The Thinker.*

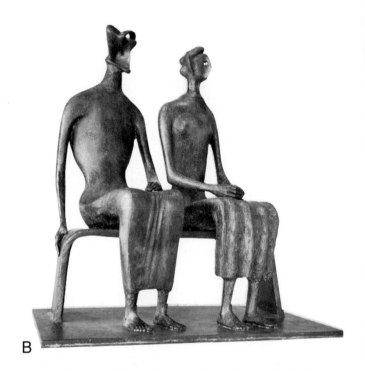

B

Henry Moore, *King and Queen*, 1952-53. Bronze, 63½" high (161 cm). Hirshhorn Museum and Sculpture Garden, Smithsonian Institution, Washington, D.C.

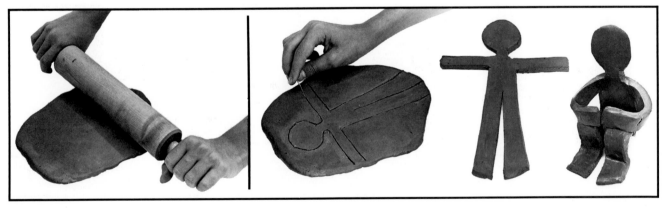

D

Slab method: Roll out a slab of clay. Cut out a figure. Bend it. Add details.

Make a sculpture of yourself. Show how you like to sit when you are thinking very hard.

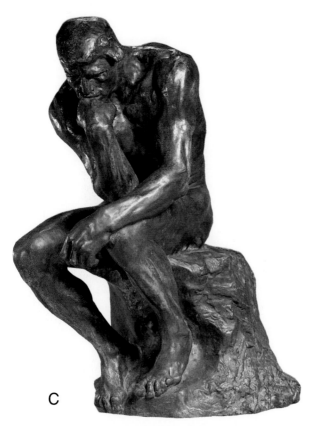

C

Auguste Rodin, *The Thinker*. Bronze, 28⅛ × 14⅜ × 23½"
(72 × 36 × 60 cm). National Gallery of Art, Washington, D.C.
(Gift of Mrs. John W. Simpson, 1942).

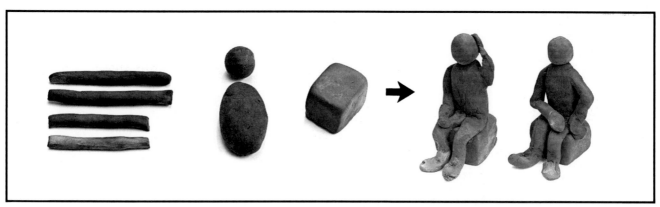

E

Coil method: Make parts for the body. Long, round pieces of clay are called **coils**. Bend the coils at the middle to make bent arms and legs. Pinch the ends of coils for hands and feet. Join all parts firmly.

Artists who make sculpture are called sculptors. Sculptors learn to look at and think about all sides of their work. Do you know why?

Most sculpture is planned so we can walk around it. We can see the front, back and sides of the sculpture.

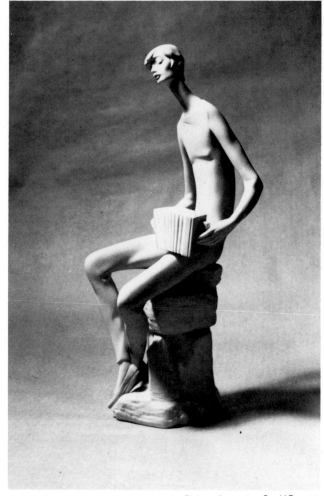

A

Photographs courtesy Gerald Brommer.

All of these photographs show the same sculpture. The artist made each side of the sculpture look different.

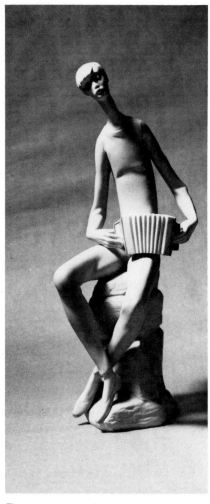

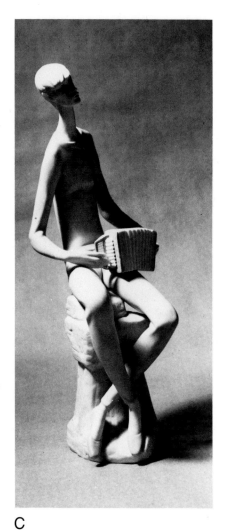

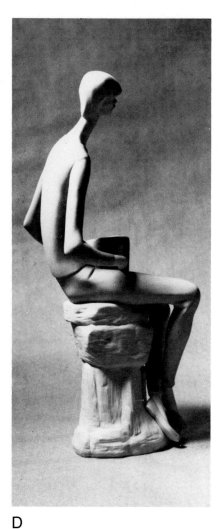

B

C

D

Notice that the head, neck, arms and legs seem to bend and turn. You can see curved forms in every view. The artist made these curved forms seem to flow around the whole sculpture.

You can make a sculpture of a person or an animal. Bend parts of the body so your sculpture seems to move. Plan your sculpture so each side has some bends or curves.

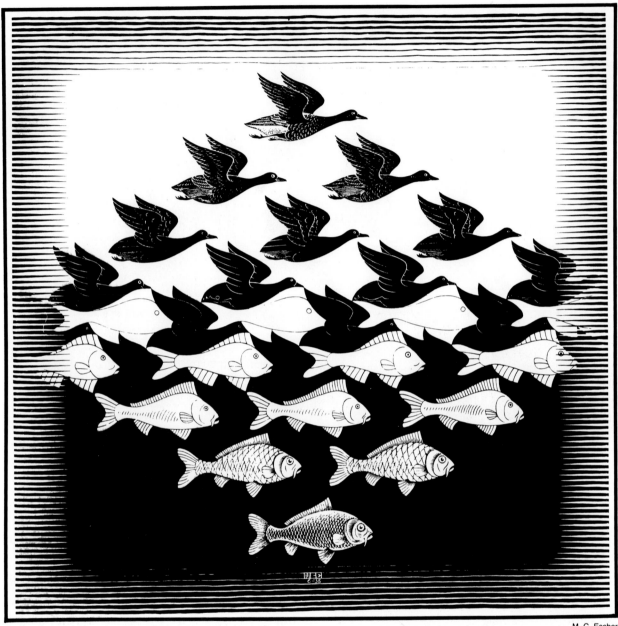

A

M. C. Escher

The artist M.C. Escher created this picture of birds and fish. Look at the black birds. Then look at the white shapes between the birds. Do some look like the shapes of fish?

B

Now look at the white fish. Do you see the black shapes between the fish? Do some of the shapes look like birds?

The **main shapes** in this picture are the black birds near the top and the white fish near the bottom. The artist has also planned the **background shapes** so that they are interesting to see.

94

Artists often say that background shapes can be just as interesting as the main shapes in artwork.

Look at the jewelry in picture C. The artist used a saw to cut a main shape from some metal. The hole in the metal made it an interesting necklace piece. The cut-out shape then was glued to a piece of wood to make an interesting second necklace.

C *Pendants.* Photograph: Jay D. Kain, Mansfield State College, Pennsylvania.

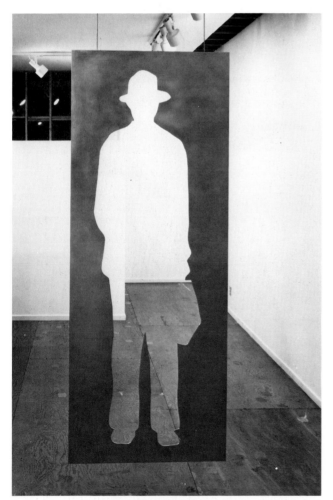

D Jonathan Borofsky, *Man With a Briefcase.* Aluminum cut-out, 89¼ × 35½ × ¼″ (227 × 90 × .6 cm). © Gemini G.E.L., Los Angeles, California, 1982.

An artist created this sculpture. The background shape was a large rectangle of aluminum. He cut out the main shape, which looks like a man.

Today you will draw and cut out a shape from stiff paper. You will use your background shape for a stencil.

Read through the next lesson so you can plan your stencil. The main and background shapes of a stencil must be carefully planned.

95

46

Printmaking
Stencil Prints

There are many ways to make art prints. Some art prints are made with a stencil. A **stencil** is a guide for drawing or printing a shape. A stencil makes it easy to create the same shape many times. A stencil can be cut from paper, thin plastic or thin metal.

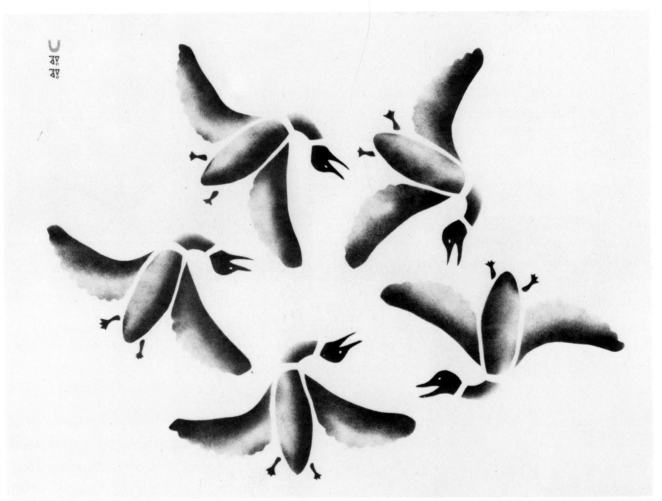

Iyola, *Circle of Birds*, 1966. Stencil, 22¼ × 19½″ (57 × 50 cm). Toronto Dominion Bank.

A

An Inuit artist made this stencil print. Each bird was printed from the same stencil. The stencil was cut from one piece of paper.

A stencil is a sheet of paper with holes. Paint or ink is pressed through the holes. A stencil similar to this was used to make the art print of birds.

B

96

You can make a stencil print. Begin with a simple sketch. Draw it again so that the main shapes don't connect with each other. Cut out all of the shapes you have drawn.

C

For a strong stencil, leave 1/4″ (.6 mm) wide paper strips between the cutout parts.

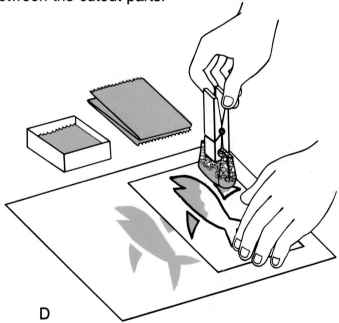

D

Put a small amount of paint on a sponge. Press the sponge very lightly. Your paint should look like this example. You can also make stencil prints using chalk or crayons.

E

Clay
Action Sculptures

Many sculptors like to show the action of people or animals. Sculptors often make small models in clay or wax to study action and to try out ideas. Sometimes the small model is saved by making a cast (a copy) of it in bronze.

It is difficult to make a clay or wax model that shows action. Thin parts break easily. Find out how five sculptors solved this problem.

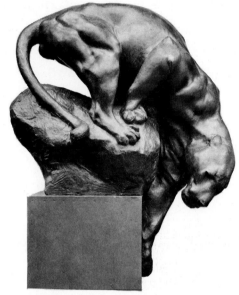

A Anna Vaughn Hyatt Huntington, *Reaching Panther.* Bronze, 45″ (114 cm). The Metropolitan Museum of Art, New York (Gift of Archer M. Huntington, 1925).

Anna Hyatt Huntington used a strong base for support, to show the action of a jaguar's body. Part of the base is shaped like a rock.

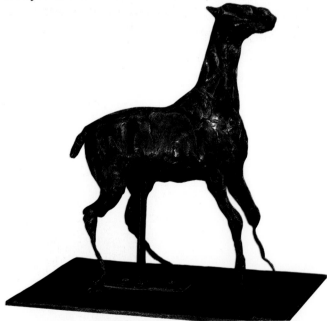

B Edgar Degas, *Prancing Horse, ca.* 1881, cast *ca.* 1924. Bronze relief, 10⅜ × 10¾ × 5″ (26 × 27 × 13 cm). Hirshhorn Museum and Sculpture Garden, Smithsonian Institution, Washington, D.C.

Edgar Degas put a rod into his sculpture of a horse to help support it. The rod is called an **armature.** Can you explain why the artist needed an armature for the prancing horse?

Study the action in Mahonri Young's sculpture of a boxer. A wire armature can be used to make similar action figures. Staple the wire to a base. Add clay to the wire.

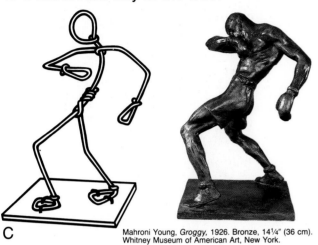

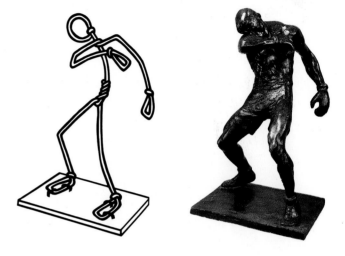

C

Mahroni Young, *Groggy,* 1926. Bronze, 14¼″ (36 cm). Whitney Museum of American Art, New York.

In Abastinia Eberle's sculpture, the broom helps show action and support the figure. In Honoré Daumier's sculpture, the cane helps support the tall figure.

You can learn to show action in sculpture. What problems must you learn to solve?

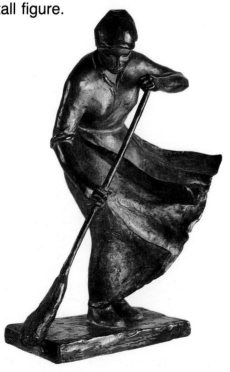

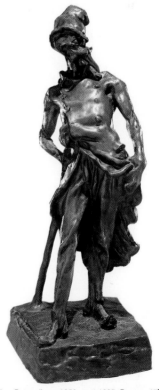

D Abastenia St. Leger Eberle, *The Windy Doorstep,* 1910. Bronze, 13⅝ × 9⅝ × 6⅜″ (34 × 24 × 16 cm). Worcester Art Museum, Massachusetts.

E Honoré Duamier, *Ratapoil, ca.* 1850, cast 1925. Bronze, 17⅜ × 6½ × 7¼″ (44 × 16 × 18 cm). Hirshhorn Museum and Sculpture Garden, Smithsonian Institution, Washington, D.C.

Artists can create a feeling of action in their work. In this sculpture, you can see the horse diving down while the cowboy arches back. Frederick Remington planned this sculpture to show motion. His artwork shows frontier life in Western America.

Notice the path your eyes follow as you look at this sculpture. You can draw this path using arrows. Artists often begin a sculpture by planning the main path of movement. Can you guess why?

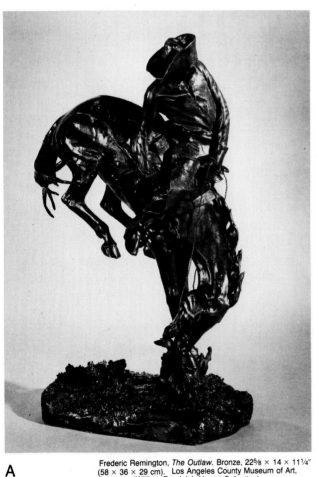

A

Frederic Remington, *The Outlaw.* Bronze, 22⅝ × 14 × 11¼" (58 × 36 × 29 cm). Los Angeles County Museum of Art, California (William Randolph Hearst Collection).

These paths of movement are shown in Frederick Remington's sculpture. Can you find other hidden lines or paths of movement?

In these camel sculptures, the paths of movement give a feeling of motion. Nancy Graves made these sculptures about the same size as real camels. The sculptures are **life-size**. These works of art are at the National Gallery of Canada, in Ottawa.

Motion or action can be shown in many ways. Can you make your sculpture show motion?

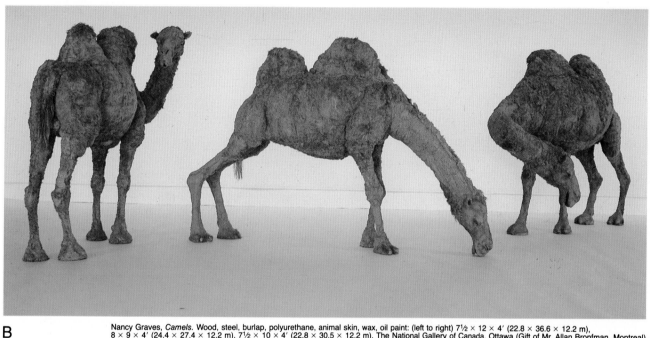

B

Nancy Graves, *Camels.* Wood, steel, burlap, polyurethane, animal skin, wax, oil paint: (left to right) 7½ × 12 × 4′ (22.8 × 36.6 × 12.2 m), 8 × 9 × 4′ (24.4 × 27.4 × 12.2 m), 7½ × 10 × 4′ (22.8 × 30.5 × 12.2 m). The National Gallery of Canada, Ottawa (Gift of Mr. Allan Bronfman, Montreal).

Each camel twists and turns in a different way. What other paths of movement do you see in these sculptures?

A Ad Reinhardt, *Red Painting,* 1952. Oil on canvas, 78 × 144″ (198 × 366 cm). The Metropolitan Museum of Art, New York (Arthur H. Hearn Fund, 1968).

Some artists like to create paintings about colors and shapes. Their artwork is carefully planned.

Ad Reinhart's painting has red rectangles. How are the shapes arranged?

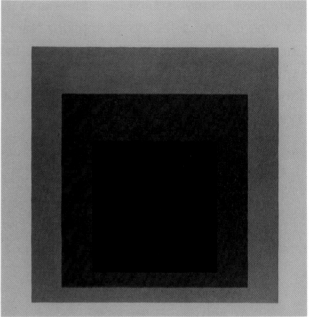

B Josef Albers, *Homage to the Square: Silent Hall,* 1961. Oil on composition board, 40 × 40″ (102 × 102 cm). Collection, The Museum of Modern Art, New York (Dr. and Mrs. Frank Stanton Fund).

The four squares in Joseph Albers's painting are different colors. Which colors seem to advance or come toward you? Which colors seem to recede or go away from you?

Rectangles and squares are examples of **geometric** shapes. Geometric shapes can have curved edges or straight edges. The edges are usually smooth and even. Some geometric shapes are in picture C. There are many others.

circle oval ellipse

square triangle rectangle

C

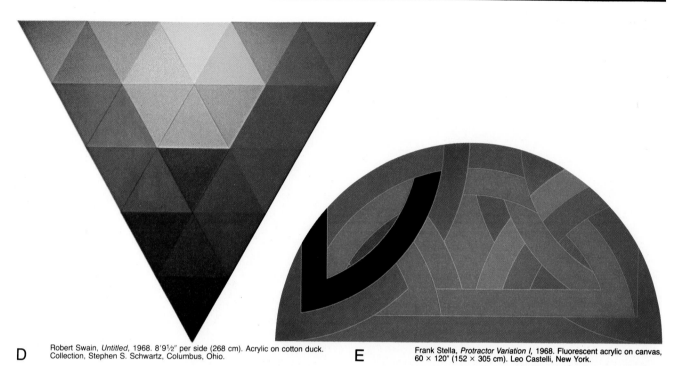

D Robert Swain, *Untitled*, 1968. 8′9½″ per side (268 cm). Acrylic on cotton duck. Collection, Stephen S. Schwartz, Columbus, Ohio.

E Frank Stella, *Protractor Variation I*, 1968. Fluorescent acrylic on canvas, 60 × 120″ (152 × 305 cm). Leo Castelli, New York.

Robert Swain's painting of triangles is also shaped like a triangle. How did he change the colors in the small triangles? Do some colors seem to advance? Do some seem to recede?

What colors and shapes do you see in this painting by Frank Stella?

See if you can draw and color an original picture with geometric shapes. Draw just a few shapes. Use a ruler. For curved shapes, trace around the edge of a round form or use a compass.

F

G

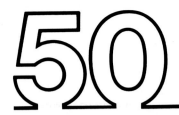

Fiber Art
Weaving

A fiber is a long, thin material that is easy to bend. Thread, yarn and rope are fibers. Some artists use fibers to create art. They create fiber art.

A

Carol Hartsock.

Some fiber artists are weavers. Weaving is done in an over-and-under pattern. The fabrics in your clothes are woven from many tiny threads.

In this weaving, the fibers are thin strips of paper. The artist cut two photographs into narrow strips. Then she wove the strips back together.

104

B

C

D

Today you will choose two magazine pictures and weave them together. Try to find two pictures that are alike. How are these pictures alike?

E

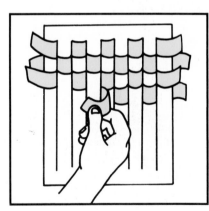

1. Fold one picture in half. Draw lines about 1" (2.5 cm) apart. Begin at the fold. Cut the lines with scissors. Do not cut all the way to the edge of the paper. This will be your paper loom.

2. Draw lines 1" (2.5 cm) apart on your second picture.

3. Cut one strip at a time from your second picture. Weave each strip into your paper loom. Be sure to weave all of the strips in the same direction.

Living With Art
Modern Sculpture

Today artists can create large sculptures from sheets or tubes of metal. The pieces of metal are cut out, bent and welded together. Many people may help assemble the sculpture. Sometimes cranes are used to lift very heavy parts.

Artists must carefully plan a very large sculpture. Sometimes artists make small models of the sculpture. The model helps them try out ideas and solve problems. The model helps them see how the sculpture will look from all sides.

A Louise Nevelson, *Transparent Horizon,* 1975. Black painted cor ten steel, 20′ (6 m). The Pace Gallery, New York.

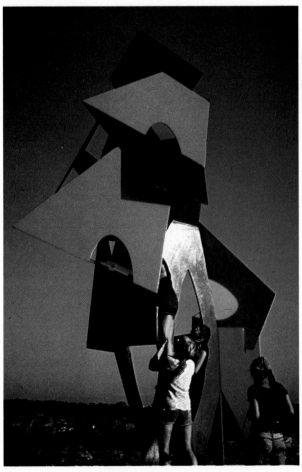

B George Sugarman, *Kite Castle,* 1973. Painted steel, 18′ (5.5 m). Hammarskjold Plaza, New York. Photo courtesy Robert Miller Gallery, New York.

Louise Nevelson designed this sculpture for a school. The sculpture is about 10 feet (3 m) tall. How tall are you?

George Sugarman designed this sculpture for a plaza in New York City. The steel has been painted different colors. The sculpture is 18 feet (5.5 m) tall.

Today you will make a model for a sculpture. Use stiff paper. Learn to bend, cut and fold the paper. Imagine that your sculpture could be made from steel and placed in a park or plaza.

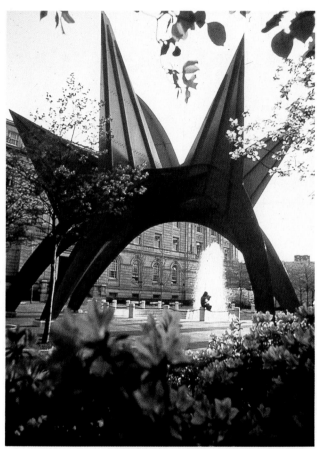

Alexander Calder, *Stegosaurus*. Steel plate, 50′ (15.2 m).
Burt McManus Memorial Plaza, Hartford, Connecticut.

C

Alexander Calder designed this sculpture for a plaza in Hartford, Connecticut. The sculpture's title is **Stegosaurus**. Can you imagine how a small paper model could be used to plan this steel sculpture? The finished sculpture is 50 feet (15 m) tall.

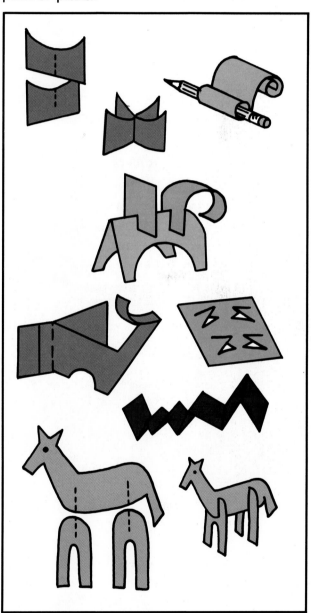

D

Drawing
Space and Distance

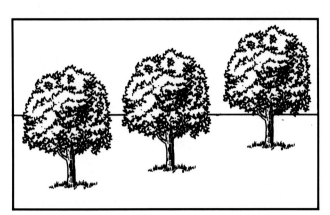

A 1. Draw shapes up the page.

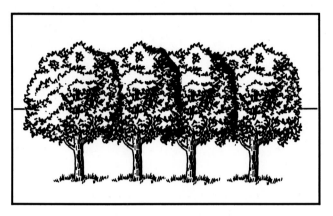

2. Overlap the shapes.

Study the four diagrams of trees at the top of this lesson. The diagrams show four ways artists create the illusion of space and distance in a landscape, seascape or cityscape.

How did Grant Wood create the illusion of space and distance in his painting? Look for some similarities between the four diagrams and parts of his painting. Point to the similarities that you see.

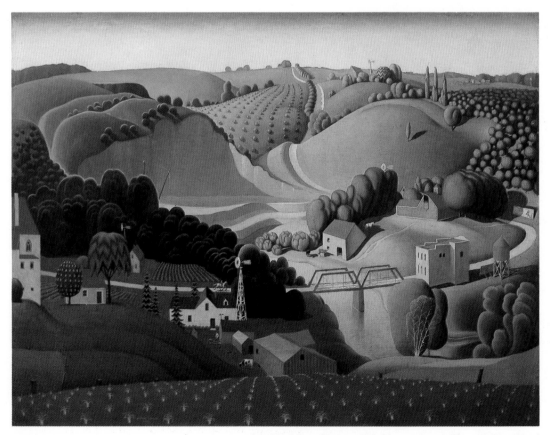

Grant Wood, *Stone City, Iowa*, 1930. Oil on wood panel, 30¼ × 40" (77 × 102 cm). Joslyn Art Museum, Omaha, Nebraska (Gift of Art Institute of Omaha, 1930).

B

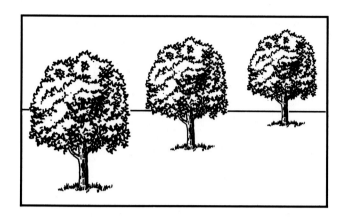

3. Make shapes smaller.

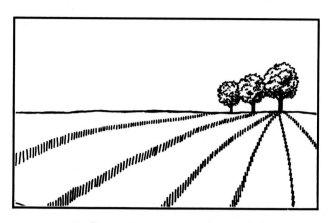

4. Draw lines toward a point.

Which parts of Edward Hopper's painting look nearest to you? Why? Which parts look far away? How did the artist make those parts look farther away?

The four diagrams show four ways to draw objects so they look near or far away. Try to draw a scene that shows space and distance. Use at least one of these four ways.

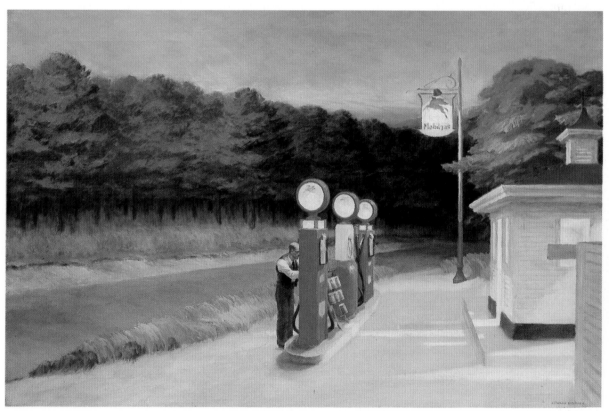

C

Edward Hopper, *Gas*, 1940. 26¼ × 40¼″ (67 × 102 cm). Collection, The Museum of Modern Art, New York (Mrs. Simon Guggenheim Fund).

A

| square | triangle | rectangle | circle | oval | ellipse |

B

Almost everything you see has a definite shape. You can learn to draw many things by looking for the main shape first.

Look at the shapes in picture A. Learn to name these shapes. Can you find these shapes in the trees shown in picture B?

Julie Bozzi, *Frontage Road-Fort Worth, Texas*, 1982. Watercolor, 3 × 10″ image on 11 × 14″ paper (8 × 25 cm; 28 × 36 cm). Courtesy the artist.

C

An artist created this watercolor. It shows trees and bushes near a highway in Fort Worth, Texas. What shapes can you find in the trees that she painted?

Most of the forms you see in nature have a definite "skeleton" or structure. You can learn to draw many things by studying the skeleton or structure.

Study the structure of trees. Look at the way branches grow from the trunk. Look at the structures in picture D. Can you match them with the trees in picture B?

D

E

Harry Callahan, *Chicago*, 1950. Photograph. Pace-MacGill, New York.

An artist took this photograph of trees in winter. Have you seen trees with structures like these?

Practice drawing trees. You might begin with the main shapes. You could also begin by drawing the skeleton structures.

111

Drawing
Forms and Textures

B

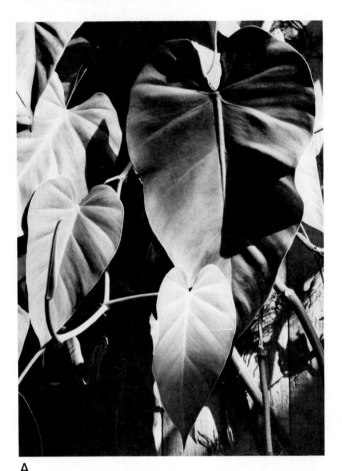

A

Artists study light and shadows. Light and shadows help us know if an object is flat or round, rough or smooth, shiny or dull.

What are the lightest and darkest areas in pictures A and B? Can you explain why light and shadows help us see the forms and textures of objects?

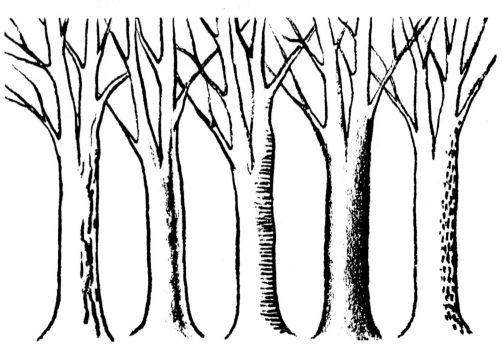

C

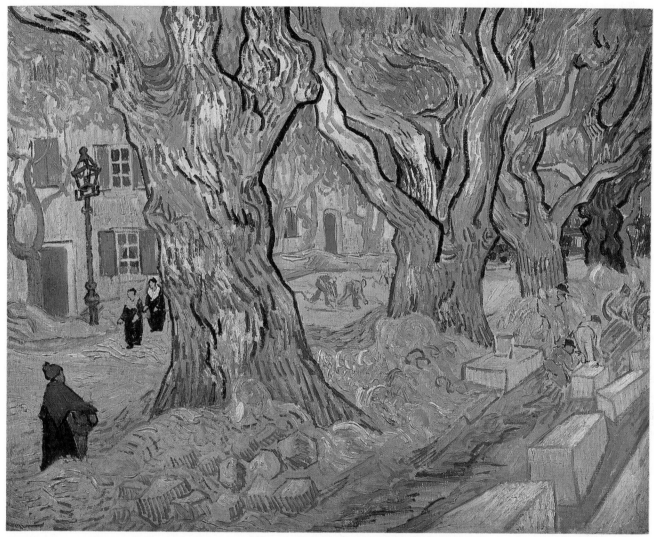

D Vincent Van Gogh, *Road Menders at Saint Remy,* 1889. 28 × 36½″ (71 × 93 cm). The Phillips Collection, Washington, D.C. (Acquired: Miss Elizabeth Hudson, 1949).

Artists invent ways to create art that shows light and shadow. The five tree trunks in picture C are shaded in different ways. Which trees have been shaded so they look rough? Which trees look as though they have smooth bark? Why are all the trees dark on one side and lighter on the other side?

Vincent Van Gogh, a Dutch artist, created this painting of a road with large trees. How did he help you see the rough twisting forms of the trees?

Try to shade the drawing you made in the last lesson. Use your pencil or crayons inventively, as artists do. Add light or dark areas to show the forms and textures of objects.

Drawing
Buildings

Have you ever watched people construct a house or a large building? What are some of the first things you see when a new building is constructed?

A

B

Buildings are made from wood, steel, bricks and other materials. What materials were used to construct your school and classroom?

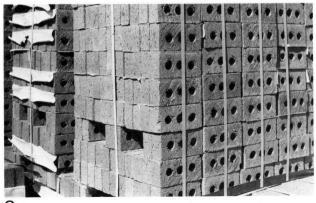

C

An architect is an artist who designs buildings. Architects plan the size and shape of walls, doors and windows. They plan every space in a building.

Architects try to plan buildings that are nice to see and use.

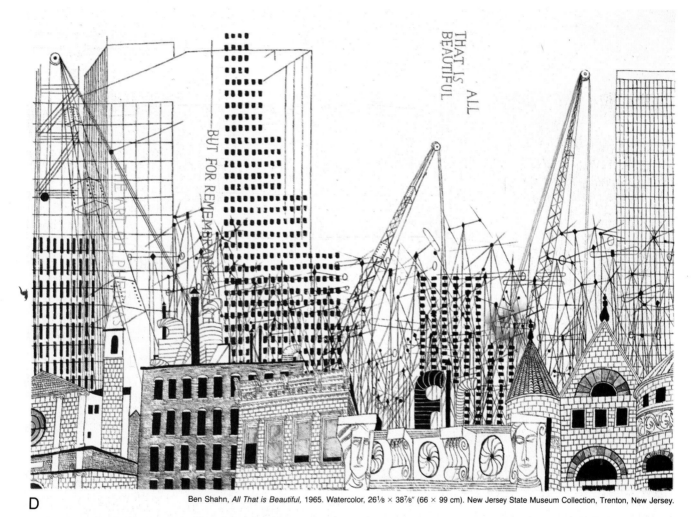

D

Ben Shahn, *All That is Beautiful*, 1965. Watercolor, 26⅛ × 38⅞" (66 × 99 cm). New Jersey State Museum Collection, Trenton, New Jersey.

Ben Shahn, an artist, wanted people to plan their towns better. How does his drawing show this idea?

Draw a picture about buildings. You might draw your home or show a building that people are constructing. You might draw some trucks filled with bricks, lumber or cement.

56 Living with Art
Improving a City

There are many kinds of art. People with special art skills planned this business district in San Francisco. Architects planned the main buildings and spaces around them.

A sculptor made the figures for the fountain. Industrial designers planned the benches, lamps and many products sold in the stores. Can you find other kinds of art in this scene?

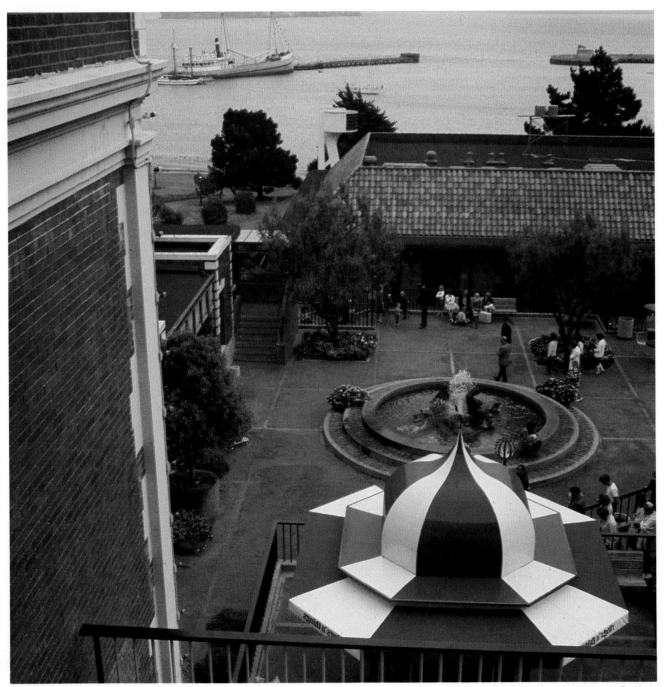

Ghirardelli Square, San Francisco. Photograph: Fred Lyon.

A

People who have jobs in art can help make a town attractive and lively. Other citizens are very important, too. In San Antonio, Texas, the citizens decided to change the downtown riverfront which had been ugly.

Today, San Antonio has a beautiful riverside park that every citizen can visit. Architects and other kinds of artists helped to plan the improvements. Are there other ways everyone can improve and care for a town?

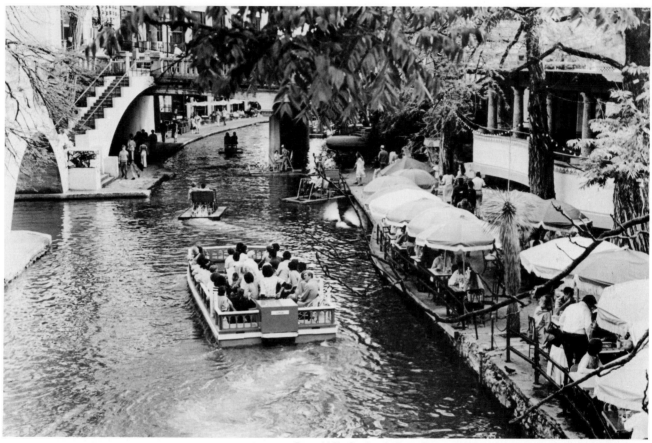

B

Paseo del Rio, San Antonio, Texas. Photograph courtesy San Antonio Convention and Visitors Bureau.

C

What parts of your town are attractive or beautiful? What improvements would you like to see? Why? Draw a picture that shows the most attractive part of your town.

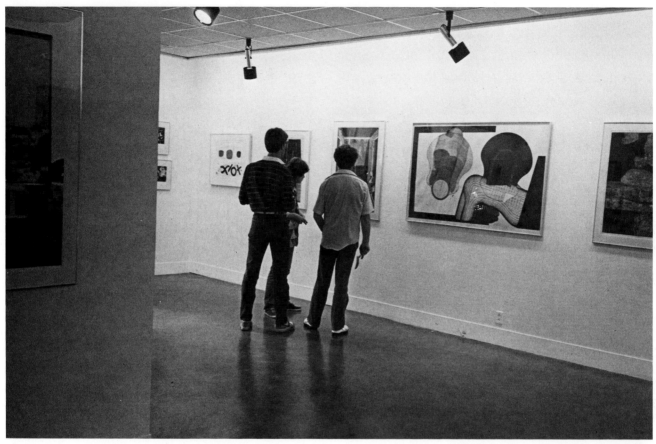

A

Photo courtesy Cincinnati Art Academy, Cincinnati, Ohio.

Many artists like to discuss their artwork. They like to find out what other people like best and why. Today you will talk about some of your best artwork. Then you will choose artwork for a class art show.

Here are some points to remember when you talk about your own art and artwork by other students.

1. What kind of art idea is shown? Is the art meant to look real or imaginary? Is the art a special kind of design? Was it made to express a definite mood or feeling? Remember that each kind of art idea should be judged in its own way.

2. What parts of the artwork match the art idea? Do the colors, lines and shapes go with the art idea? Do the textures and patterns also go with the art idea?

3. What parts of the artwork show good effort and something your class has learned about in art?

After you have talked about your artwork, choose your best work for the class show. You might try to finish any incomplete work, too. In the next lesson you will mount your artwork for the class art show.

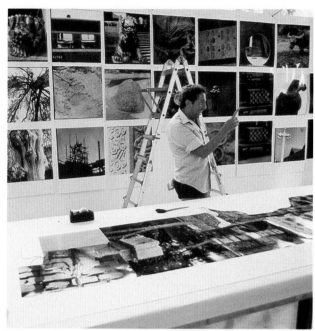

B

Robert Rauschenberg setting up an exhibit of his work.

The artist in picture B is hanging up his artwork in an art gallery. He created all of the artwork that will be displayed.

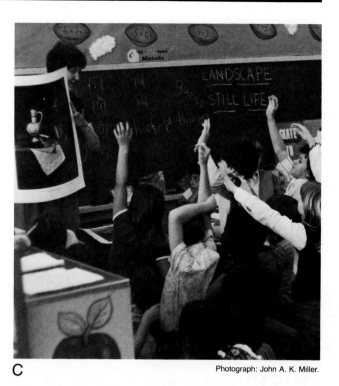

C

Photograph: John A. K. Miller.

The students in picture C are learning to talk about artwork. They are remembering art ideas they have learned.

An Art Show
Displaying Your Best Artwork

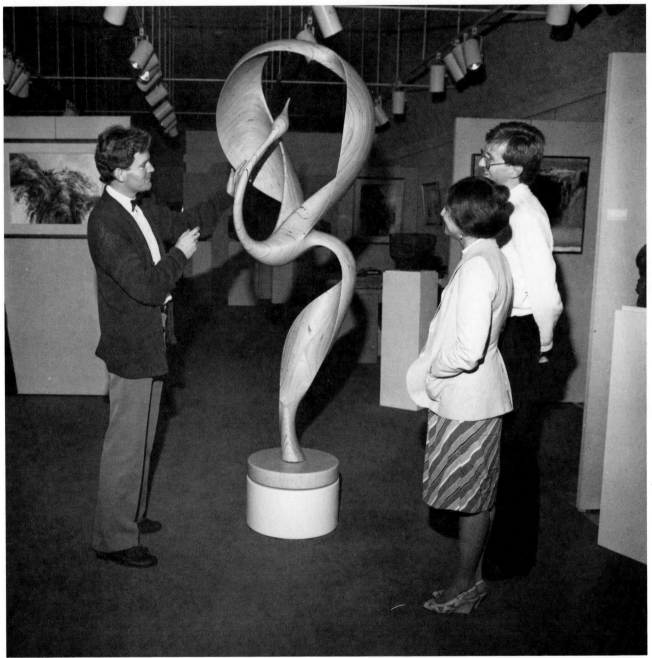

A

Courtesy Louis Newman Galleries, Los Angeles, California.

Artists display their best work for others to see. They plan their art shows. They frame or mount their best art. Sometimes they put sculpture or crafts on stands.

Each work or art has a label. The label tells the name of the artist and title of the artwork. The label also tells what materials were used to create the artwork.

Have you attended art shows? Where do artists in your town have art shows?

Learn to mount and label your artwork.

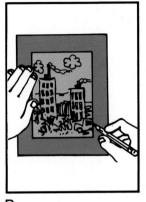

Place your picture on the background paper. Make sure the borders are even. Then lightly trace around the four corners of your picture.

B

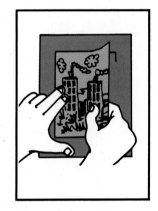

Turn your picture over. Put paste near the edges. Put paste from corner to corner in an X. Wipe your hands. Then paste your picture down carefully.

C

Use a sheet of paper for the label. Write neatly.

Name:_____

Title of work:_____

Materials:_____

What I learned:_____

D

Review
Looking at Art

This large painting was created by Pieter Bruegel, an artist who lived in Belgium more than 300 years ago. You can see about eighty games, sports and tricks in this painting. Try to find and name some activities that have not changed in the past 300 years.

A Standing on one's head

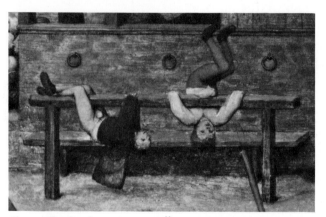

B Swinging on a rail

C Walking on stilts

D Leapfrogging

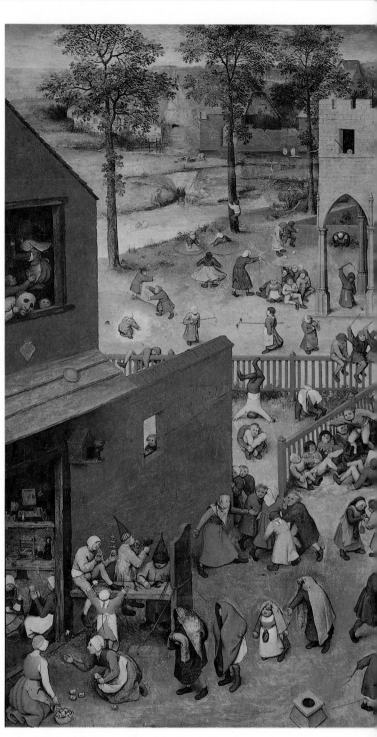

E

Pictures A, B, C and D are details. Try to find them within the large painting. You might place a viewfinder on the large picture and move it around to look for the details.

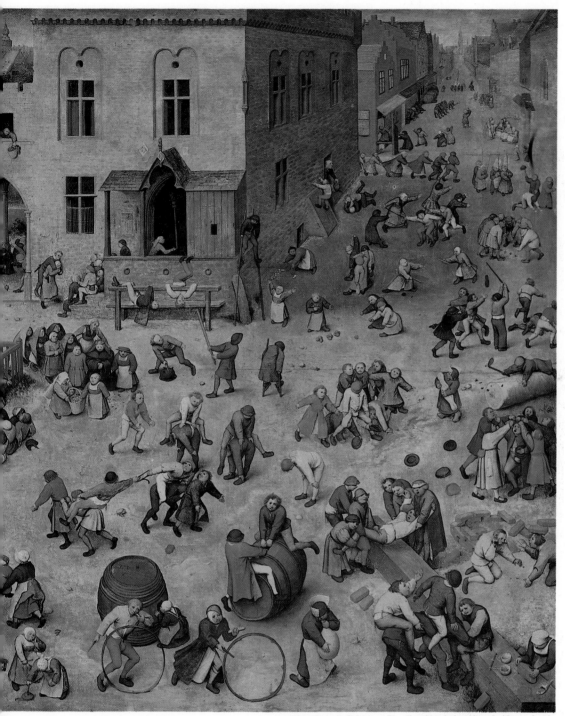

Pieter Bruegel, *Children at Play*. Kunsthistorisches Museum, Vienna, Austria.

Bruegel planned his picture very carefully. He placed most of the children in groups. This helps you see what the children are doing.

The artist also planned his painting with paths of movement. A path of movement is a "hidden" line that leads your eye from one part of the picture to another part.

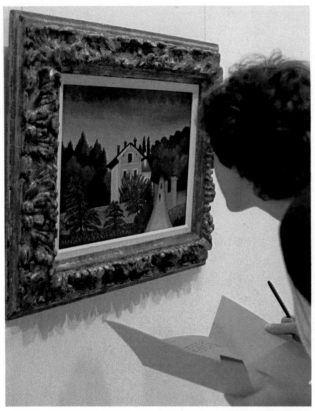

A

Photograph: Elaine Stone.

What will you do this summer? Will you stay at home or take a trip? You might want to visit an art museum. An art museum is a place where you can see works of art such as paintings, sculpture, art prints and ceramics.

Some art museums have special summer activities for families and children your age.

B

From *Design Dialogue* by Jerry Samuelson and Jack Stoops, 1983

You can look for art in your environment. You might go on art hunts with friends. You might draw pictures of things you see. If you have a camera, you could take photographs. An artist took this photograph of a neon sign.

C Eliot Porter, *Frostbitten Apples. Tesuque, New Mexico. November 21, 1966.* Dye-transfer photograph. The Metropolitan Museum of Art, New York (Gift of Eliot Porter in honor of David H. McAlpin, 1979).

You can look for beauty in nature. You might find a quiet place where you can think about art. Look for very small differences in the lines, shapes, colors and textures of the things you see there.

D

You could also create art this summer. You might try to draw or paint pictures outdoors. Some towns have art classes in recreation centers.

You can make art from natural materials. You might try weaving long, thin vines or grass. You might collect some lovely rocks, shells or feathers. Perhaps you could make jewelry from some of the things you find.

Glossary

The following art words appear in bold face type within this book. The numbers indicate the first lesson in which the word is used.

armature (AR-ma-chur). A wire that is placed inside a sculpture to hold it up. 47

artisan (ART-ah-zahn). A person skilled in creating hand-made objects. 26

art museum (art mu-ZE-em). A building where artwork is shown and carefully saved. 60

asymmetrical (AY-sim-eh-trick-all). Artwork that looks balanced when the parts are arranged differently on each side. 13

background (BACK-ground). In a scene or artwork, the part that looks farther away or behind other parts. 42

background shapes (BACK-ground shapes). Shapes that look farther away or behind other shapes. The shapes that usually attract little attention. 45

carving (KARV-ing). A way to make sculpture by cutting away clay, wood or stone. 45

close-up view (KLO-sup view). Artwork in which objects look very near. 50

coil method (koil METH-od). Using long round pieces of clay to create artwork. 43

coils (koils). Long round pieces of clay. 43

collage (koh-LAUSH). Artwork made by pasting pieces of paper or other materials to a flat surface. 11

contrast (KOHN-trast). Great difference between two things. A light color has contrast with a dark color. 10

cool colors (KOOL KOL-ers). Colors that remind people of cool things. Varieties of blue, green and violet. 6

craftsworker (KRAFTS-wor-ker). A highly skilled person who creates artwork by hand. 26

crayon etching (KRA-ahn ETCH-ing). Scratching through one layer of crayon to let another layer of crayon show. 4

cubism (KYUB-ism). A style of art in which shapes or forms seem to be divided or have many edges. 19

foreground (FOR-ground). In a scene or picture, the part that seems near or close to you. 42

geometric shapes (je-uh-MET-rik shapes). Shapes that have smooth, even edges. 49

graphic designer (GRAF-ik de-SIHN-er). An artist who plans the lettering and artwork for books, posters and other printed materials. 35

illustrator (IL-us-tray-ter). An artist who creates pictures for books, magazines and the like. 2

intermediate colors (int-er-MEED-ee-at KOL-ers). Colors that are made from a primary and a secondary color (red-orange, yellow-orange and the like). 9

life-size (life-size). Of the same size as the natural, real or original (a life-size sculpture of a camel). 48

limners (LIME-ners). Early American artists who painted signs, houses and portraits.

logo (LO-go). A visual symbol for a business, club or group. 36

main shapes (mane shapes). The shapes which are seen first and usually are most important. 45

montage (mahn-TAZH). A special kind of collage, made from pieces of other pictures. 11

neutral colors (NEW-trel KOL-ers). In artwork, neutral colors are brown, black, white and gray. 6

original (oh-RIJ-en-al). Artwork that looks very different from other artwork; not copied. 1

Pop art (pop art). A style of artwork that includes advertisements or other popular, often-seen images. 19

portrait (POR-tret). Artwork that shows the face of a real person. 15

portrait bust (POR-tret bust). A sculptured likeness of a person's head, neck and chest. 33

primary colors (PRI-mer-ee KOL-ers). Colors from which others can be made: red, yellow and blue. (In light, the primary colors are red, green and blue). 9

product design (PRAHD-ukt de-ZIHN). The art of planning the appearance of items that will be produced in factories. 36

profile (PRO-file). Something seen or shown in artwork from the side view (as a profile of a head). 15

proportion (proh-PORE-shen). The size, location or amount of something as compared to that of another (a hand is about the same length as a face). 16

pure colors (pyur KOL-ers). Colors seen in the rainbow or when light passes through a prism: red, orange, yellow, green, blue, violet. 6

Realism (Re-ah-liz-em). A style of art that shows objects or scenes as they might look in everyday life. 19

related colors (ri-LATE-ed KOL-ers). Colors that are next to each other on a color wheel. 9

relief sculpture (ri-LEEF SKULP-chur). Sculpture that stands out from a flat background. 33

secondary colors (SEK-on-dair-ee KOL-ers). Colors which can be mixed from two primary colors; orange, green, violet. 9

shade (shade). The darkness of colors (as dark or very dark blue). 10

shading (SHAYD-ing). Slight changes in the lightness or darkness of a color or value. 10

slab (slab). A form that is solid, flat and thick. 43

slab method (slab METH-od). Creating a form (as in clay) by using a slab or joining slabs. 43

statue (STACH-u). A sculptured likeness of something (as of a person or animal). 33

stencil (STEN-sell). A paper or other flat material with a cut-out design that is used for printing. Ink or paint is pressed through the cut-out design onto the surface to be printed. 46

still-life (still life). An artwork that shows non-living things such as books, candles or the like. 18

studio (STEW-di-o). The place where an artist creates artwork. 30

symmetry (SIM-et-ree). Parts arranged the same way on both sides. 13

technique (tek-NEEK). A special way to create artwork, often by following a step-by-step procedure. 4

tint (tint). A light color. A color mixed with white. 10

value (VAL-yu). The lightness or darkness of a color (pink is a light value of red). 10

warm colors (WARM KOL-ers). Colors that remind people of warm things. Varieties of red, yellow and orange. 6

woodcut (WOOD-cut). An art print created by carving into a smooth block of wood, inking the wood and pressing paper against the ink. 40